Richard Shone

VINCENT VAN GOGH

With 40 color plates

ST. MARTIN'S PRESS NEW YORK

Published in the United States of America in 1978
by St. Martin's Press, Incorporated,
175 Fifth Avenue, New York, N.Y. 10010

© Blacker Calmann Cooper Ltd, 1977
This book was designed and produced by
Blacker Calmann Cooper Ltd, London

Library of Congress Catalog Card Number: 77–9210
First published in the United States of America in 1978

Library of Congress Cataloging in Publication Data
Shone, Richard.
Vincent van Gogh.
(Art for all)
1. Gogh, Vincent van, 1853–1890. 2. Painters –
Netherlands – Biography. I. Shone, Richard.
ND653.G7S445 759.9492 77–9210

ISBN 0–312–83674–0

Printed in Spain by Heraclio Fournier, S.A.

Introduction

THE CONTINUING AND WORLD-WIDE POPULARITY of van Gogh is one of the most curious phenomena in the history of this century's taste. On the surface several other painters would seem to have very much more in their favour if subject matter be the standard of consideration. The voluptuous girls of Renoir have a healthy eroticism about them quite absent in van Gogh's work. Toulouse-Lautrec offers a glimpse into a recognizable underworld, witty, colourful and lively, with an immediacy of impact in his posters which continues to fascinate. Munch and Beardsley and, rather differently, Turner, Constable and Monet have a more obvious appeal and there is a host of lesser artists whose subjects are virtually their only claim to wide success. What has van Gogh to offer in these terms? A pair of old shoes, a deal chair, the gaslit terrace of a back-street café. As one commentator has pointed out, it is his early work from Holland that should have a more universal appeal in terms of subject – the intense scenes of fields and heathland, deserted gardens, labourers and peasant families. Yet, for most people van Gogh is the painter of Provençe, of cornfields, sunflowers, cypresses.

The vast popularity then of van Gogh has little to do with nostalgic appeal, with sentimentality or the presentation of highly pleasurable or arrestingly dramatic images. But it is this very popularity which makes looking at his pictures increasingly difficult, so overlaid are they with associations and almost exhausted through reproduction. Only by concentrating on the physical facts of the pictures before us, on the unusual simplicity of handling and subject when compared to many of his European contemporaries, can we begin to understand his intentions; it is probably only through them that we will find the answer to his wide appeal. As van Gogh himself said, 'It was "only pictures full of painting" that I did'. That his popularity should in the main rely so much on purely pictorial – 'painterly' – features makes him unique among the world's best known artists.

The first picture reproduced in this book dates from 1884 and the last from 1890. Although the distance travelled is great in the actual look of the pictures, there are no violent jumps and few blind alleys on the way. Nothing looks experimental; all bear the stamp of that over-whelming confidence with which he pursued his vision. To understand how he achieved this mastery, it is worth looking at the story of his early life.

The years before 1880, when van Gogh decided to be a painter, were spent in a continual search for a way of living that would enable him to be self-supporting and independent, yet involved in everyday life in a manner that was spiritually fulfilling, and that went beyond an adherence to conventional values – of church, school, business and 'culture'. After years of despondency, painting became the focus of this search.

When van Gogh was born on 30th March 1853, his father Theodorus was a pastor in the Dutch Reformed Church in the Brabant village of Groot-Zundert near the Belgian border. It was a predominantly Roman Catholic area – in fact he was responsible for about one hundred people only in a community of six thousand. His wife Anna Carbentus had given birth to a dead child exactly a year before Vincent was born. Five children followed in the next fourteen years including in 1857, Theo, the brother who became his support and

confidant and to whom was addressed one of the great correspondences of the world.

The woods and heathland of the Brabant countryside retained their hold on Vincent all his life. His love for birds, insects, plants and flowers – conveyed in his letters with detailed tenderness – remained a constant joy: 'We shall always have something of the fields and moors of Brabant in us,' he wrote to Theo. Vincent attended the village school and, from the age of eleven, a boarding-school in Zevenbergen and, later, another in Tilburg, both in the Brabant district. At sixteen he entered the world of his uncle and namesake, a conspicuously successful art dealer and partner of Goupil & Co., a well-known Paris firm. A branch of Goupil's had been opened in The Hague and there Vincent was apprenticed. Four years later, when his brother joined Goupil's in Brussels, Vincent wrote, 'I am sure you will like it, it is such a fine business . . . I am glad that we shall both be in the same profession and in the same firm'. In the following year, 1873, Vincent was transferred to the London branch and there enjoyed one of the happiest, least troubled years of his life. He walked to work and back each day from his lodgings in Stockwell, went on the river, explored London and the countryside on foot (once walking to Brighton and back), read widely in French and English literature and further familiarized himself with the painters of the contemporary Dutch school, such as Jacob Maris, Israels, Anton Mauve (his cousin by marriage), with the Barbizon painters, then much collected in England, and with English art – Millais and the Pre-Raphaelites, Herkomer and many of the black and white illustrators whose work he collected. Rembrandt, Delacroix and Millet were already becoming heroes.

This enjoyable period came to an end when, after months of silent devotion, Vincent told his landlady's daughter, Ursula Loyer, that he loved her. She turned him down. It was the first in a line of refusals in his emotional and working life from which he emerged scathed but unembittered. He had a remarkable capacity for forgiveness – as can be seen in his later attitude to his family and relatives, to the Church which rejected him, to painters like Mauve who had no feeling for his aims. From this time on Vincent became increasingly fanatical in his religious beliefs, filling his letters with biblical quotations and allusions; his family became alarmed, his employers distressed; he was moved to Goupil's in Paris but his rudeness to customers increased as his interest in commerce declined. In April 1876 he was dismissed. After a brief visit to his family at the parsonage of Etten, Vincent accepted a post as schoolmaster in Ramsgate, Kent and two months later became an assistant to a Mr Jones, a Methodist minister and teacher in Isleworth, west of London. It was here that his compassion grew for the poverty-stricken people he came across on his errands about London; he also preached for the first time.

On his return to Etten for Christmas, he was persuaded to take a position in a bookshop in Dordrecht but again was unsatisfied. At last his family decided he must be given the opportunity to enter the Church and he went to Amsterdam to receive instruction as preparation for entry into the University. But he longed to be among the poor: 'May God give me wisdom . . . to finish my studies as quickly as possible and be ordained, so that I can perform the practical duties of a clergyman'. He eventually abandoned the course in July 1878 but was allowed to study for three months at an evangelists' school in Brussels before he made the decision to go as a missionary to the Borinage mining district of Belgium.

It was an area of indescribable poverty and gloom in a depressing landscape. When Vincent arrived in the village of Pâturages he preached and

ministered to the community with such enthusiasm that he was noticed with approval and transfered for a six month period to the town of Wasmes. As a preacher however he was ineffectual and halting; the exalted self-sacrifice and energy of his ministering were largely incomprehensible to the mining families and he came to be regarded with suspicion by the Church. In an orgy of self-abasement he gave away his possessions, neglected his health, eating irregularly and living in a squalid hut. Once more he was dismissed. He remained in the area, moving to Cuesmes, continuing to preach and draw the bleak landscape and the miners and labourers of the district. Until the following year he lived in destitute misery, a period of which little is known for he stopped writing letters to Theo, with whom his relations were temporarily strained. But in July 1880 he wrote once more, a long, exceedingly moving letter describing the terrible wilderness of the previous months and proclaiming a spirit of renewal in himself using a characteristic image – that of a moulting bird hiding itself away until ready to emerge. Gradually he came to see painting as his vocation and in September he wrote again to Theo that '. . . In spite of everything I shall rise again, I will take up my pencil, which I have foresaken in my great discouragement, and I will go on with my drawing: and from that moment everything seems transformed for me'.

Vincent's inability in the face of circumstances to adapt to a life of action motivated by Christian love was transformed almost immediately into a fierce espousal of art; through painting he could express a universal love unfettered by clerical notions of respectability and 'the dignity of one's calling'. Although there were to be further disruptions – another refusal in love, misunderstandings with teachers and a worsening of relations with his family – the following years were made possible by his determination to succeed. 'Do not fear for me now,' he told Theo, 'it is such a good thing when a man has found his work'.

Initially he worked in Brussels, sharing a studio with the painter Anton van Rappard (1858–92) who, like Vincent, was an admirer of the potent naturalism of English and French illustrators and was eager to portray the Dutch landscape and people as subjects. Vincent saw himself primarily as a draftsman, hoping to earn a living from working for papers and illustrating books; even in 1883 when he was already painting in oils and excited by the possibilities of colour, he formed a plan to move again to England as an illustrator. Theo, who had sent Vincent money occasionally while he was in the Borinage, now began supporting him with regular monthly sums sent from Paris, selflessly entering into his brother's new-found vocation.

In April 1881 Vincent, then aged 28, moved to the family home at Etten, drawing the Brabant peasants, the diggers, sowers and working women, their cottages and landscape. He fell in love with his widowed cousin Kee Vos-Stricker, a love that was unreciprocated and opposed by his and her family when he pursued her to Amsterdam. At Christmas he quarrelled with his father and left for The Hague, melancholy but undeterred, more than ever convinced that 'there is a power within me, and I do what I can to bring it out and free it'.

The Hague period was extremely important in Vincent's growing technical mastery as a painter and increasing independence as a man. He came to know several Dutch artists and was helped by Mauve; he read voraciously the novels of Dickens and Balzac, of Hugo, George Eliot and Zola; he tackled watercolour and lithography, began painting in oils with increasing application and even managed to sell some drawings. Soon after his arrival he had met a pregnant prostitute called Sien who already had one child; he took pity on her, housed her, her child and baby and she modelled for him; the

scandal of this ménage reached his family and alienated him from the cultured circles of The Hague where his family name was respected. Sien eventually returned to her old way of life and Vincent, recovering from a period of ill-health, went off alone to the province of Drenthe in North Holland for three months. Late 1883 found him once more in the prickly atmosphere of his family, now settled in the parsonage of Nuenen. He used an outhouse in the presbytery garden as a studio, only seeing his parents at meal times and then often eating apart from them in a corner. 'They feel the same dread about taking me in the house,' he wrote to Theo, 'as they would about taking a big rough dog. He would run into the room with wet paws . . . he will be in everybody's way. *And he barks so loud.* In short he is a dirty beast. . .' He did however make friends with some of the peasants and weavers of the district and began a whole series of studies which culminated in the grim masterpiece of 1885, *The Potato Eaters* (*plate 3*). Through nursing his mother after an accident, his domestic situation considerably improved, only to be reversed again by a further unfortunate love affair involving a neighbour and family friend who attached herself to Vincent. Soon afterwards some sort of reconciliation took place between the Pastor and his son just before the Pastor's sudden death in the spring of 1885. By the end of the year Vincent was in Antwerp, having left his own country for the last time.

Although his stay in Antwerp was short, it was decisive; an intense study of Rubens helped to lighten, if not to clarify, his colour; he bought several Japanese paintings on silk to hang in his room (from which he painted a view of rooftops with an emphatic linear organization suggested by those oriental works); his growing interest in developments in France suggested the possibilities of a wider range of subject matter. In the early spring of 1886 he became ill and it was partly in the hope of recovering under his brother's care that he left in March for Paris. He had four more years to live.

To have spent the bulk of this short introduction on that period of van Gogh's life and work which, if he had died in 1886, would in all probability be forgotten, may seem unwisely disproportionate. But only by recounting the vicissitudes and obstacles of those years can we see how he stripped himself of his family and country, traditional morality and religion, how he rid his system of much that was irrelevant to his purpose as an artist, and how hard he worked to produce those paintings in which he expressed his feelings about life with the utmost directness. The rest of the story is well known. He spent two years with Theo in Paris, where he was influenced by the Impressionists, Pointillism and Japanese prints. In February 1888 he moved to Arles on the Rhône in Provençe, painting for ten months with supreme assurance, the period of his greatest work; the unsettling autumn visit of Gauguin ended in Vincent's first mental crisis and the cutting off of part of his ear. A year followed spent in the asylum of St. Paul on the edge of St. Rémy, some miles from Arles, a year interrupted by severe bouts of madness in one of which he attempted suicide; in May 1890 he travelled north to Paris and visited Theo, now a married man and father of a baby boy; he then moved to Auvers-sur-Oise, twenty miles from Paris, under the care of Dr Gachet (*plate 38*) and in two months painted seventy pictures, mainly landscapes and portraits, and made many drawings and watercolours and one etching.

On July 27th he shot himself. Fatally wounded in the groin, he died on the 29th with Theo by his side. The local priest refused to allow the painter's body to be conveyed to the graveyard on the parish hearse. Six months later Theo died and was buried by his brother's grave.

Van Gogh's development as a painter may be traced in the sequence of illustrations and accompanying notes which follow. As a popular creator of

images that are forceful, simple and transparently sincere, he is often regarded as an intuitive late-developer, who by some miracle was endowed with a painter's eloquence which externalized his importunate, inner convictions. There is truth in this but the whole impact of his work is considerably diminished if other considerations are neglected. With the gradual publication of van Gogh's letters to his brother, to Gauguin and to Bernard, a picture was established which corrected the prevalent myth of an instinctive genius-madman-saint. Their language is that of an exceptionally articulate man, as sophisticated on the problems of painting and as alive to contemporary thought and opinion as anyone. They show too that, although extraordinarily individual, van Gogh was fully alive to several of the aesthetic questions of his time. Alongside such painters as Munch, Toulouse-Lautrec and Gauguin, he re-introduced a more humanitarian subject matter, moving away from the bourgeois world depicted by the Impressionists; he was convinced of the importance of a personal art ('The artist is slave neither to the past, the present, nature nor even to his neighbour,' wrote Gauguin. 'Himself, always himself.'); he saw direct formal expression and a new conception of colour as an antidote to a society deemed materialistic.

During his lifetime, van Gogh's reputation was restricted to a small circle of admirers, mainly fellow painters such as Pissarro, Signac and Gauguin. One article on his work by the critic Albert Aurier appeared in January 1890 and one painting was sold in Brussels in the following month. After his death an appreciation by Octave Mirbeau appeared in 1891. Both articles stressed the symbolic aspects of van Gogh's painting, variously relating him to Bernard, Maurice Denis, Gauguin and others, and placing him firmly in the French Post-Impressionist school; little account was taken of his Dutch origins which we now see as being of paramount importance. In the twenty or so years following his death, several European movements in paintings drew inspiration from his work. In France, where there was an important Paris retrospective exhibition in 1901, the Fauves were inspired by his use of pure colour and an insistence on the right of the artist to exaggerate form and invent colour in the service of an inner necessity. In Germany, where his work was exhibited in 1905 in Dresden, the Expressionists, while not insensible to his discoveries in design and colour, were profoundly impressed by the emotional vibrancy of his handling of paint and an autobiographical reading of his subject matter. In 1907 and 1908 the work of a fellow Dutchman Piet Mondrian was revitalized by his example with immense consequences for painting in this century. Van Gogh's own confidence was not misplaced when, on several occasions, he asserted the importance of his work for the painters coming after him.

Following his first mental breakdown, van Gogh realized with increasing despondency the inevitable erosion of his gifts. To succeed – and in Arles in 1888 he did little else – he needed to hold that precarious balance between the intensity of his response to the subject and the most acute control of pictorial elements. He conveys this when he tells Theo '. . . of the mental labour of balancing the six essential colours . . . sheer work and calculation, with one's mind utterly on the stretch, like an actor on the stage in a difficult part, with a hundred things at once to think of in a single half-hour'. With his increasing mental instability in 1889, his colour lost some of its radiance and his form faltered; more important became the expression of his anguished state and he realized he was losing that balance. 'For myself I can only say at the moment that I think we all need rest,' he wrote to Theo shortly before his suicide, '. . . I feel done for. So much for me: I feel this is the lot which I accept and which will not alter. . . . And the prospect grows darker. I see no happy future at all.'

1. *The Weaver*

1884. Ink and watercolour. $13\frac{1}{4} \times 17\frac{1}{4}$in ($35 \times 45$cm)

Weavers at work in a mill or at home are the subject of several paintings and drawings produced in the first months of 1884 when van Gogh was living with his family at Nuenen. Working among the people of Brabant, he thought of himself as a peasant painter, his own struggles behind the easel finding expression here through the image of the weaver behind his loom – 'a black ape or gnome or ghost who makes those ribs clatter all day long'.

Amsterdam, Stedelijk Museum

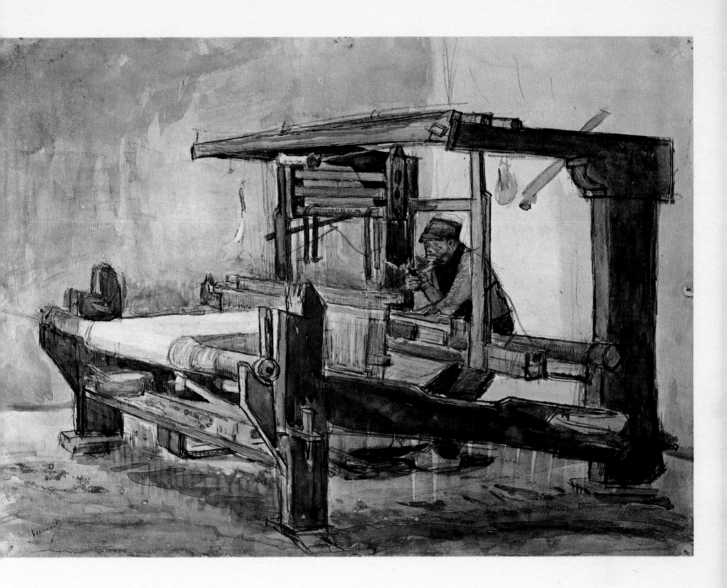

2. *The Chapel at Nuenen*

1884. Oil. 16½ × 13in (42 × 33cm)

The small Protestant church near van Gogh's parents' house is shown here as a centre of community life – the peasants are gossipping after a service. Although painting in oils was still relatively new to him, van Gogh's characteristic directness of approach, a feeling for the poetry of landscape and a simplicity of handling are already in evidence in this small canvas which was painted to amuse his mother while she was recovering from an accident.

Amsterdam, Stedelijk Museum

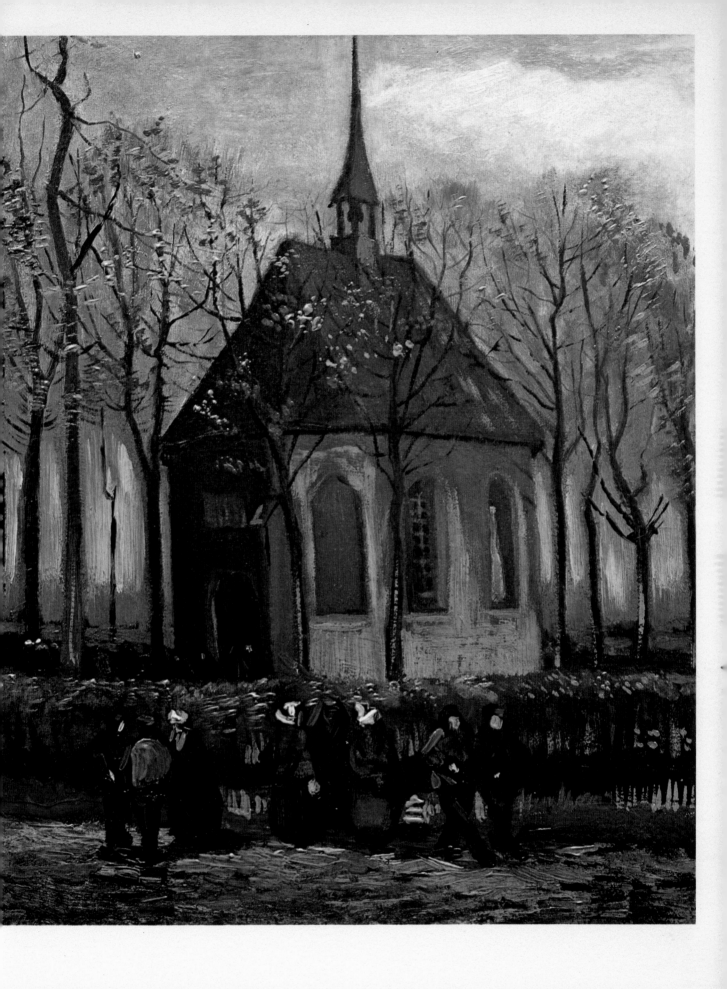

3. *The Potato Eaters*

1885. Oil. 32$\frac{1}{4}$ × 44$\frac{7}{8}$ in (82 × 114cm)

This is van Gogh's first masterpiece, a culmination of innumerable studies of peasant life in the prolific Nuenen period. It shows a poor Brabant family seated for their evening meal of potatoes and coffee, with the parents to the right and three children to the left. Vincent wrote to his brother Theo about this picture, 'I intended to keep conscientiously in mind the suggestion that these people eating their potatoes under the lamp and putting their hands in the plate, have also tilled the soil, so that my picture praises both manual labour and the food they have themselves so honestly earned . . . In painting these peasants I thought of what had been said of those of Millet, that they seem to have been painted with the very earth that they sow'.

Amsterdam, Stedelijk Museum

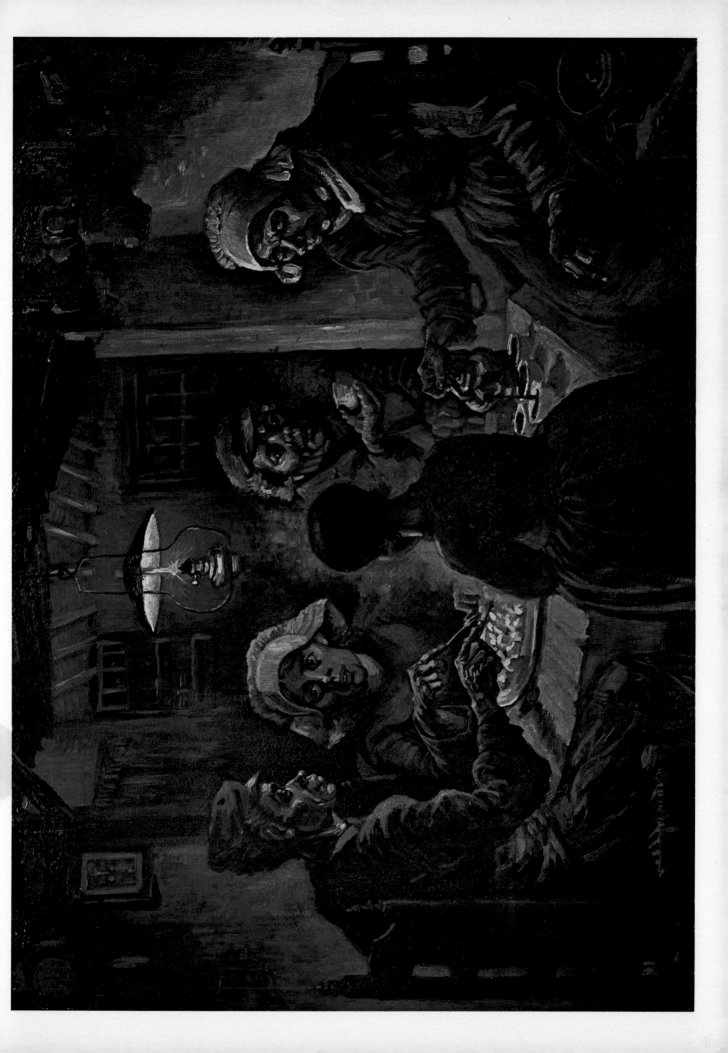

4. *Montmartre*

1886. Oil. 17$\frac{3}{8}$ × 13$\frac{1}{8}$in (44·5 × 33·5cm)

The three months van Gogh spent in Antwerp before his move to Paris in February 1886 helped prepare him, through his study of Rubens and Japanese prints, for the gradual blossoming of his art in his first months in France. In this picture, one of the first painted in Paris, a clarifying of his colour is noticeable, and there is a greater emphasis on line and a more delicate and varied handling of paint. We see here the terrace of the dance-hall, the Moulin de la Galette, made famous by Renoir and Toulouse-Lautrec, and its raised wooden platform which afforded a view, over the gardens and allotments of Montmartre, towards the heart of Paris.

Chicago, Art Institute

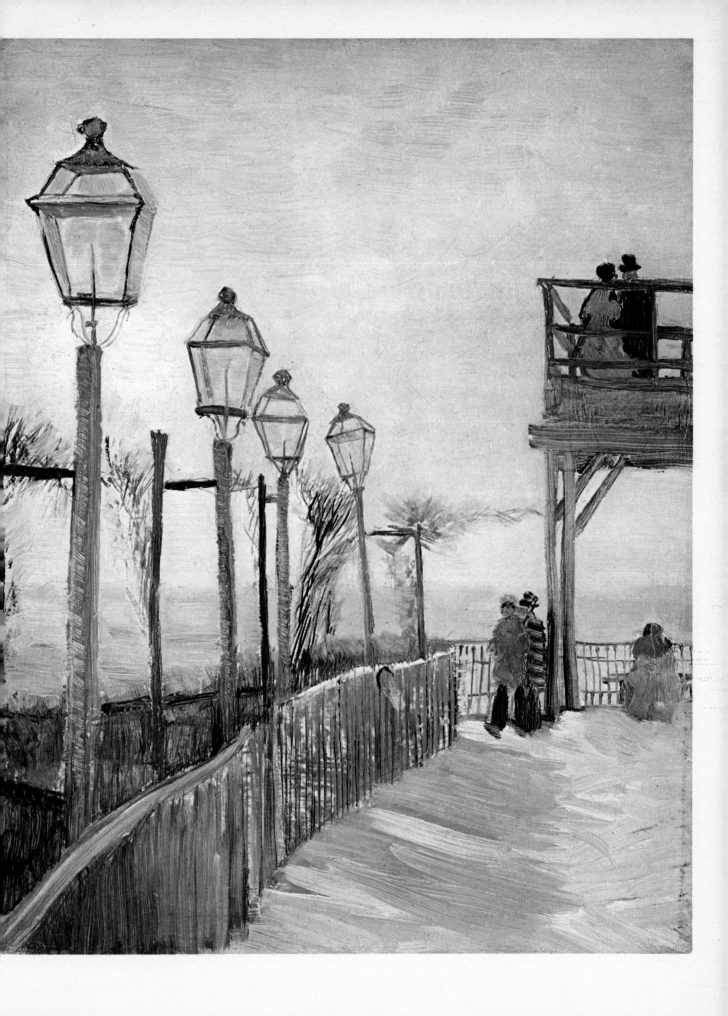

5. *Moulin de la Galette*

1886. Oil. 18 × 15in (46 × 38cm)

Although van Gogh here retains something of the earthy tonality of his Dutch landscapes, he is obviously more concerned with the depiction of light and of airy movement; the picture has an altogether more refreshing complexion with its touches of white and pure colour in the foliage, in the people on the platform (seen at close quarters in the previous plate) and the flags flying from the windmill. This is one of about twenty pictures of Montmartre from this period.

Glasgow, Art Gallery

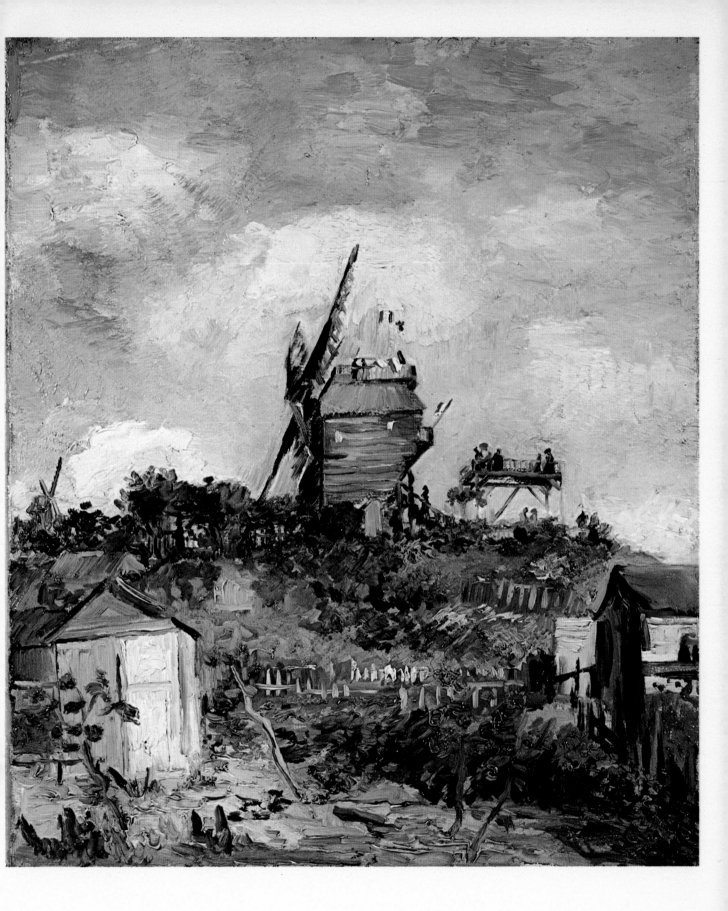

6. *Restaurant de la Sirène*
à Asnières

1887. Oil. 21 × 26in (53·5 × 63·5cm)

In the summer of 1887 van Gogh frequently painted at
Asnières, a Paris suburb by the Seine where his friend the
painter Emile Bernard (1863–1941) had a studio. During
his first year in Paris, van Gogh had studied the paintings
of Sisley, Pissarro and Guillaumin in his brother's gallery.
By the time he painted this picture, he had completely
abandoned the dark colours of his earlier work, and was
employing a full range, often broken into complementaries
in the pointillist manner; he began also to develop the
emphatic brushstrokes characteristic of his later work. The
subject matter of the Impressionists has replaced the grim
scenes of peasant life; instead of potatoes and earthenware
we have bottles of wine, absinthe and vases of summer
flowers.

Paris, Musée du Louvre

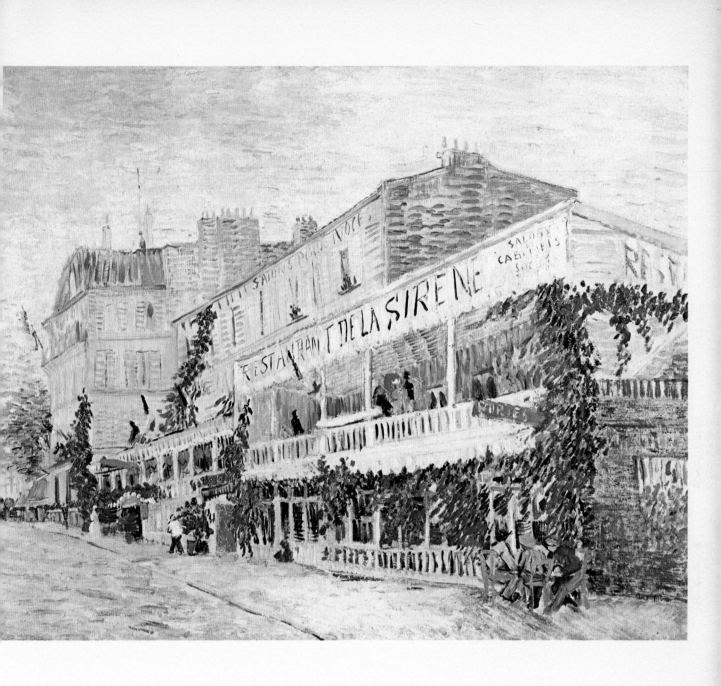

7. *In the Suburbs of Paris*

1887. Watercolour. $15\frac{1}{4} \times 21in$ (39 × 53cm)

Van Gogh's drawings, particularly of the country around Arles, are among the great landscapes of the nineteenth century. In Paris, the evolution of his drawing style is a key to some of the changes in his painting. The dark crayon of his early views of city rooftops and the boulevards has given way, under the influence of Japanese prints, to the slender ink lines and flat washes of clear colour of this drawing. He followed the example of some of his contemporaries in depicting subjects that, conventionally, were avoided – factories, tramways, blocks of modern flats and telegraph poles.

Amsterdam, Stedelijk Museum

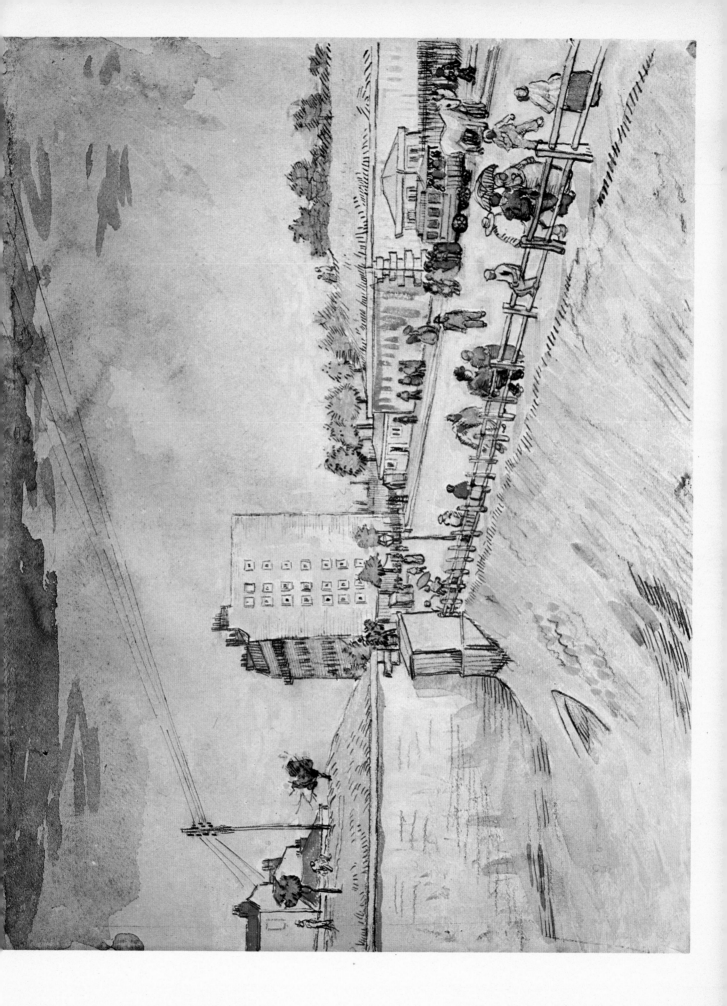

8. *Woman in the Café du Tambourin*

1887. Oil. 21¾ × 18¼in (55·5 × 46·5cm)

'Le Tambourin' was a café in the Avenue de Clichy, managed by Agostina Segatori who was briefly van Gogh's mistress; it was here that he and some friends exhibited their works. The café interior is hung with Japanese prints; at a table sits a pensive woman, reminiscent of those in Degas and Toulouse-Lautrec's café scenes. The delicacy of the drawing and spatially ambiguous background can be compared to some of Toulouse-Lautrec's work with which van Gogh was familiar. The application of paint in short strokes and dabs of colour recalls the work of Signac before he espoused the more scientific methods of pointillism.

Amsterdam, Stedelijk Museum

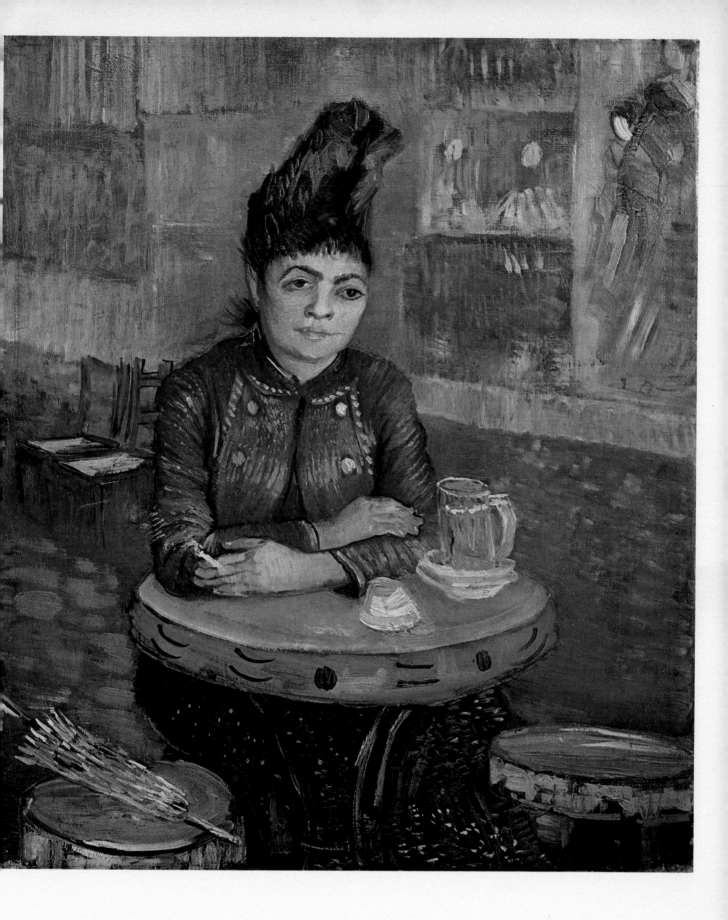

9. *Père Tanguy*

1887. Oil. 36¼ × 27½ in (92 × 75 cm)

Emile Bernard wrote of Père Tanguy as 'that smiling and honest old priest in his tiny chapel of art'. In his early sixties at the time of this portrait, Père Tanguy ran an artists' supplies shop in the Rue Chauzel, befriending many of the Impressionists and Post-Impressionists. He showed their work in his shop window, often giving them materials in exchange for their pictures. Van Gogh painted Tanguy on several occasions, twice with a selection of Japanese prints – by Hokusai, Hiroshige and others – in the background, from which the stiff, modest figure of the elderly man seems to emerge.

Paris, Musée Rodin

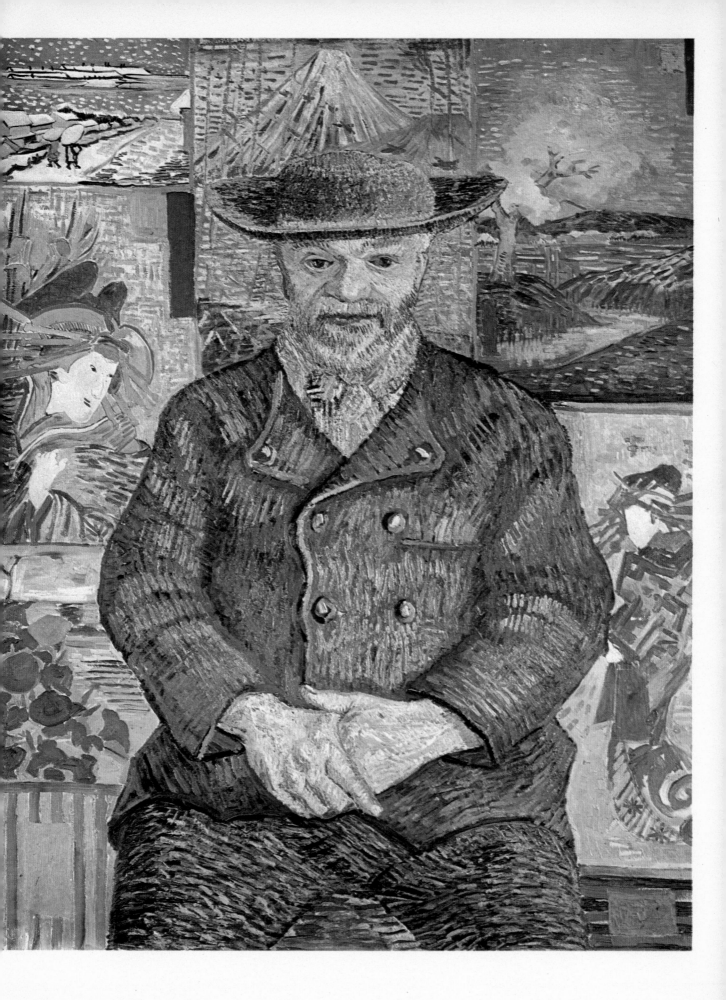

10. *Self-Portrait before the Easel*

1888. Oil. 25⅝ × 19⅞ in (57·5 × 50·5 cm)

One of over twenty self-portraits from van Gogh's Paris period, this one was completed shortly before his abrupt departure for Arles and is unusual in its inclusion of palette, brushes and easel. It shows the extraordinary development of van Gogh's personal interpretation of divided colour (seen particularly in the striated blue jacket) and the diversity of his brush strokes which define contour and volume and, at the same time, establish an emotional mood through their variety of direction.

Amsterdam, Stedelijk Museum

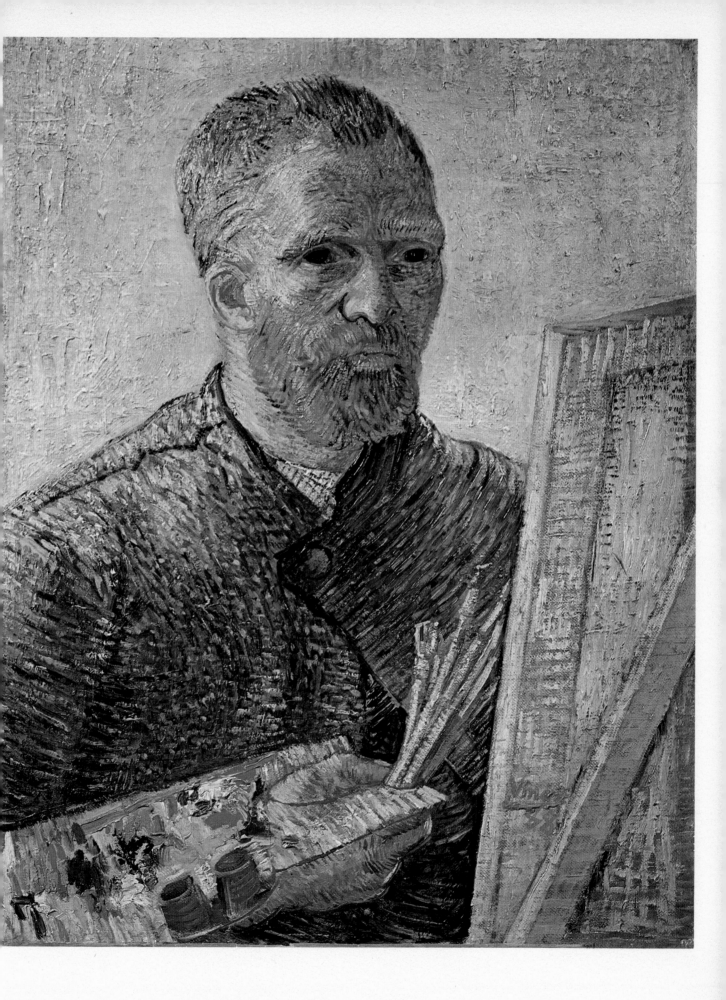

11. *The Bridge of Langlois*

1888. Oil. 21¼ × 25⅝ (54 × 65cm)

The subject of this painting is a small drawbridge just outside Arles which van Gogh painted and drew on several occasions, combining memories of the Dutch landscape with a Japanese simplicity of design. A watercolour, also in the Kröller-Müller Museum, was copied from this oil painting and sent to Theo in Paris: 'As for my work, I brought back a canvas today. It's a drawbridge with a small cart crossing it, against a blue sky. The stream is also blue, the banks orange with green grass and a group of washerwomen in blouses and gaily striped headdresses.'

Otterlo, Rijksmuseum Kröller-Müller

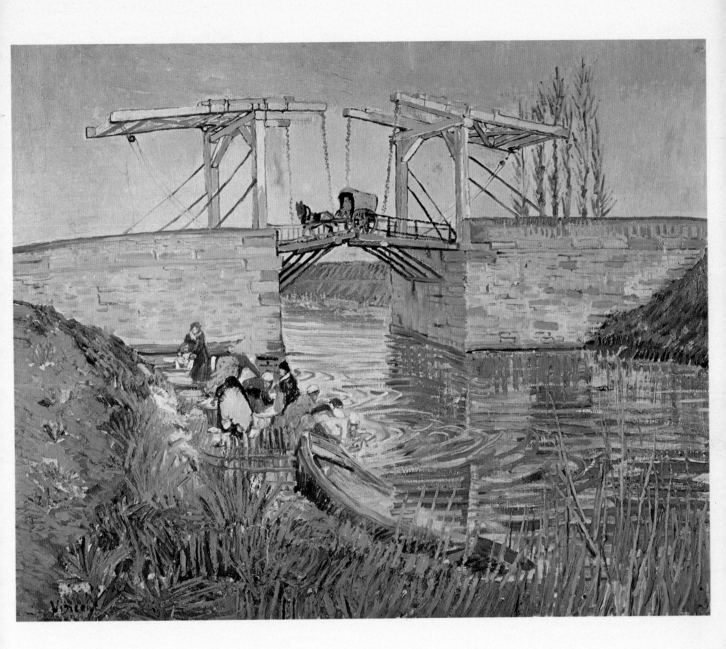

12. *Peach tree in blossom*

1888. Oil. 32 × 23½ in (81 × 60cm)

In the first Mediterranean spring he had known, van Gogh painted a series of orchards in bloom – pink flowering peach trees and pale cream pear trees, surrounded by fencing and cypresses to protect them from the *mistral*. Although a natural continuation of his French landscapes, these orchards are carried out with a more exalted luminosity and a greater degree of technical virtuosity seen, for example, in his treatment of the multi-coloured ground. In their lithe muscularity and delicate colour, the fruit trees – very swiftly painted – express something of van Gogh's revitalized state in his initial weeks in Provençe.

Amsterdam, Stedelijk Museum

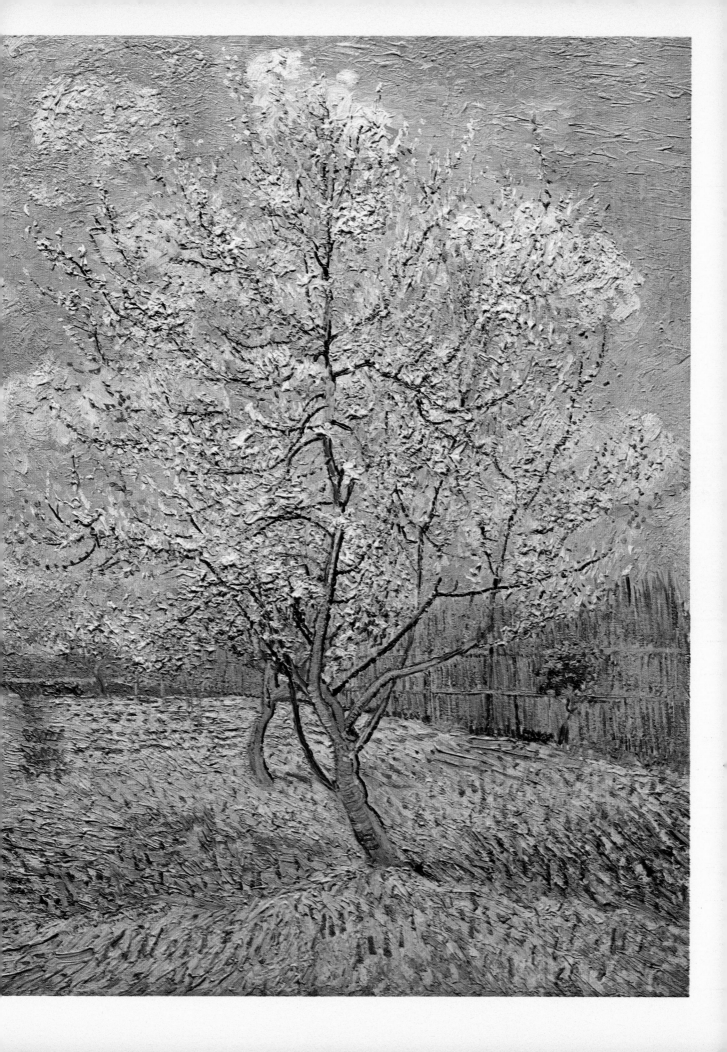

13. *View of Arles with Irises*

1888. Oil. 21½ × 25¾ in (54·5 × 65·5cm)

The first landscapes undertaken by van Gogh in Provençe
– of the orchards in blossom and fields around Arles – are
a combination of assured mastery of pictorial elements and
an ecstatic transcription of nature. 'I think the country as
beautiful as Japan', he wrote to Emile Bernard, 'in the
limpidity of its atmosphere and the brilliance of its colour'.
Here we see a ditch of irises separated from the rooftops of
Arles by 'huge meadows covered by a yellow sea of
inumerable buttercups . . . what a subject, eh? The yellow
sea crossed by that line of violet irises and in the
background the quaint little town with its pretty women?'

Amsterdam, Stedelijk Museum

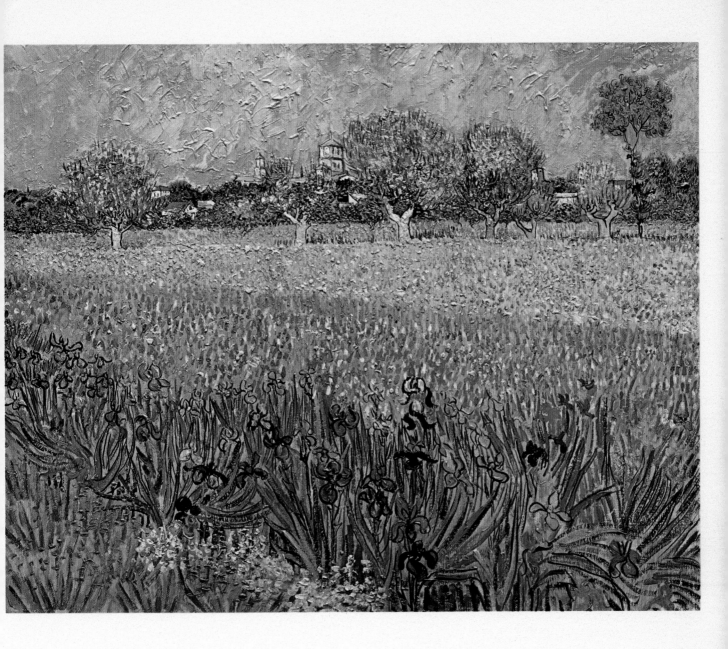

14. *Boats on the Beach at Les Saintes-Maries*

1888. Oil. 25¾ × 32½in (65·5 × 82·5cm)

In June 1888 van Gogh spent a week at the small town of
Les Saintes-Maries on the Mediterranean, some twenty-five
miles south of Arles. 'The Mediterranean has the colouring
of mackerel, changeable I mean. You don't always know if
it is green or violet, you can't even say it's blue, because
the next moment the changing reflection has taken on a
tinge of rose or grey.' These beached boats with their
delicate masts, crossed spars and primary colours under a
sky brimming with light perfectly illustrate van Gogh's
continuing aspiration to combine the strongest contrasts
of colour and form in a synthesis that would be 'comforting
as music is comforting'.

Amsterdam, Stedelijk Museum

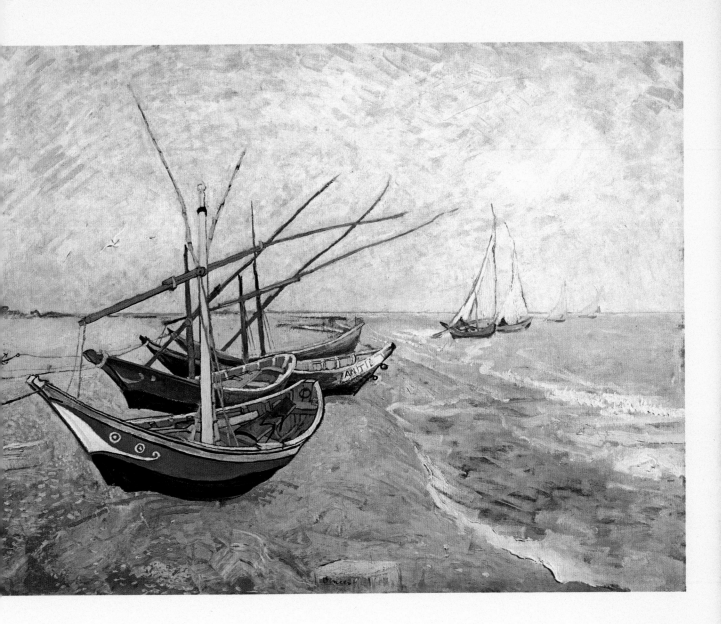

15. *View of Les Saintes-Maries*

1888. Oil. 25$\frac{1}{4}$ × 20$\frac{3}{4}$in (64 × 53cm)

Painted in the same June week as the boats of the previous
plate, the houses of Les Saintes-Maries are seen here
surrounding the Romanesque church which is viewed
from the fields behind. The cottages in the middle distance
reminded van Gogh of the labourers' huts he had drawn
in Drenthe in 1883, a further example of his continuing
memories of Holland already noted in the paintings of the
Bridge of Langlois and the windmills of Montmartre.

Otterlo, Rijksmuseum Kröller-Müller

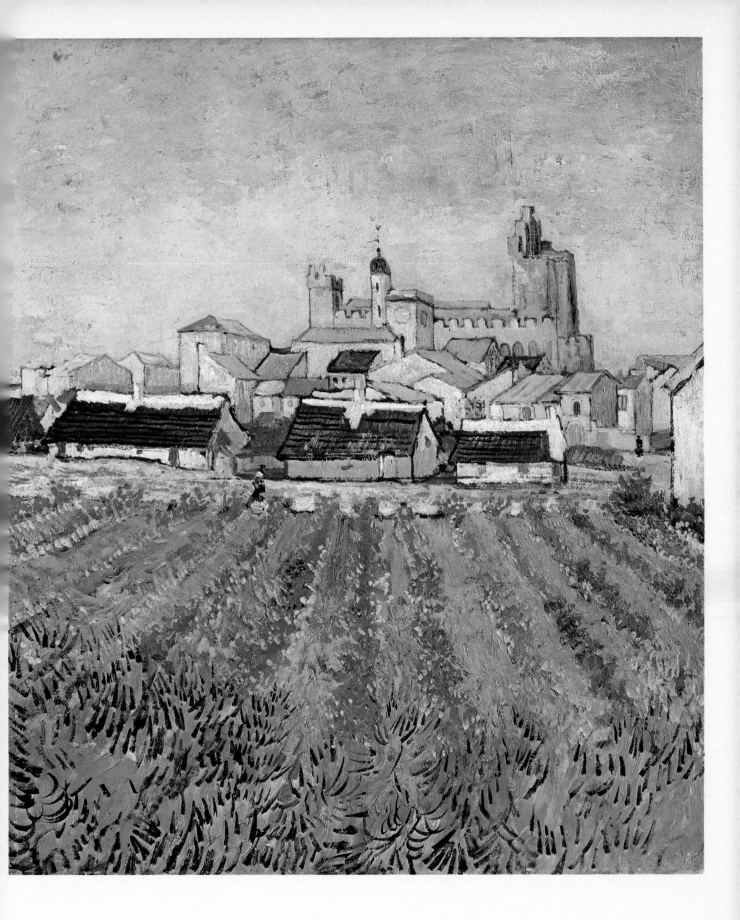

16. *La Mousmé*

1888. Oil. 28¾ × 23¾ in (23 × 60·5cm)

'I have just finished a portrait of a girl of twelve, brown eyes, black hair and eyebrows, grey-yellow flesh, the background heavily tinged with malachite green, the bodice blood red with violet stripes, the skirt blue with large orange polka dots, an oleander flower in the charming little hand,' (letter to E. Bernard, July 1888). A *mousmé* is a young Japanese girl, a name van Gogh came across when reading Pierre Loti's novel *Madame Chrysanthème*. Through the watchful expression of the girl's face, the springing rhythms of the chair echoing the girl's body and the fresh flowers which seem to grow from her lap, he has created a delicate image of emerging womanhood.

Washington, National Gallery of Art

17. *The Postman Roulin*

1888. Oil. 31¼ × 25in (79·5 × 63·5cm)

Roulin and his family were neighbours and friends of van Gogh in Arles and sat for him for a series of portraits (*plate 24*). Van Gogh became greatly attached to the postman, writing that he had 'a something which seems to say, we do not know what will happen to us tomorrow, but whatever it may be, think of me. And it does one good when it comes from a man who is neither embittered, nor sad, nor perfect, nor happy, nor always irreproachably right. But such a good soul and so full of feeling and so trustful'.

Boston, Museum of Fine Arts

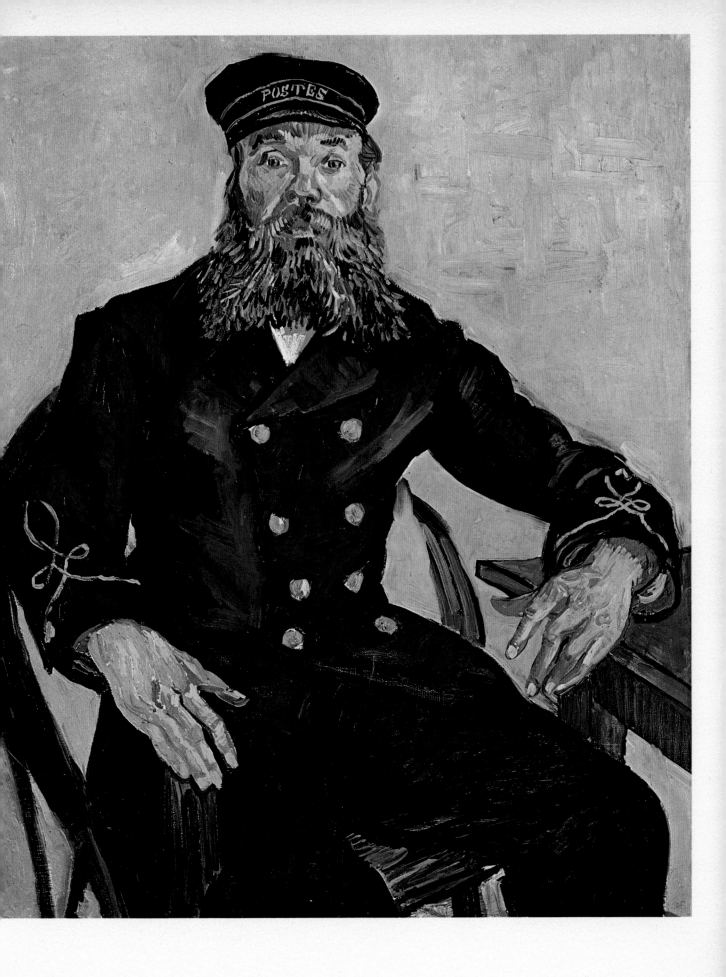

18. *Old Peasant (Patience Escalier)*

1888. Oil. $27\frac{3}{4} \times 22\frac{3}{4}$in (70·5 × 58cm)

In his first summer at Arles van Gogh produced a notable series of portraits, from the two paintings of *The Zouave* in June to the head of *Lieutenant Milliet* in September. In this portrait of an old gardener from the Camargue, van Gogh's emancipation from Impressionism is complete – 'what I learnt in Paris *is leaving me* . . . I am returning to the ideas I had in the country before I knew the Impressionists'. In the same letter to Theo he writes of Escalier as 'terrible in the furnace of the full ardours of the harvest, at the heart of the south. Hence the orange shades like storm flashes, vivid as red hot iron, and hence the luminous tones of old gold in the shadows'.

London, Christie's

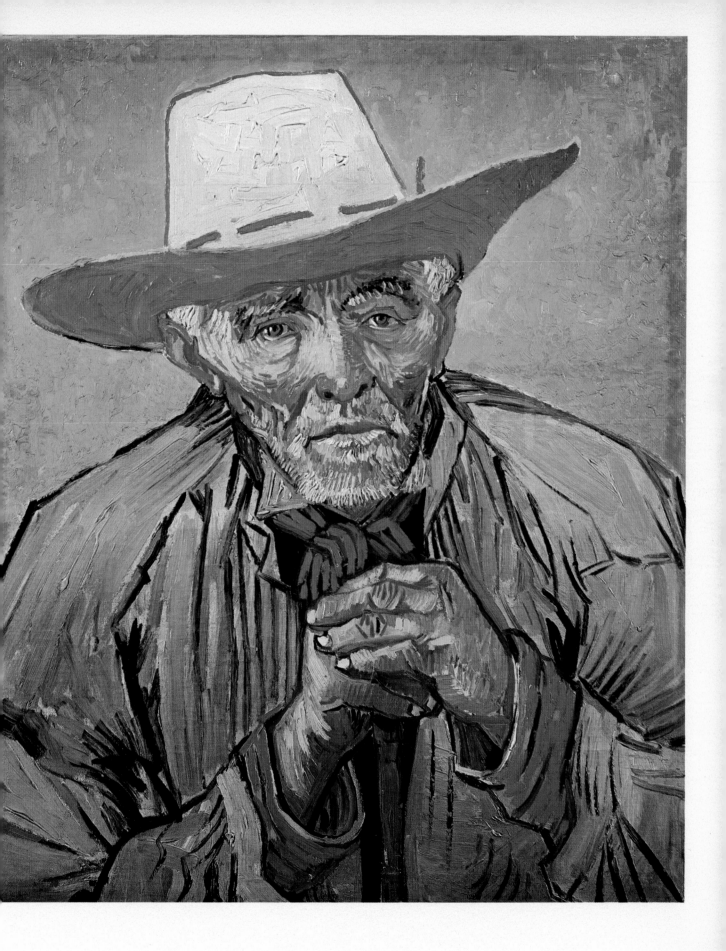

19. *Sunflowers*

1888. Oil. 37⅜ × 28¾ (95 × 73cm)

This is one of a proposed series of six paintings of sunflowers (cultivated around Arles for the oil of their seeds) with which van Gogh intended to decorate the studio he hoped to share with Gauguin and other painters. He had to work very fast – painting, as he said, 'with the rapture of a Marseillais eating bouillabaisse' – as the blooms faded quickly; in fact there are nearly as many seedheads as flowers. For van Gogh the sunflowers were brimming with vitality and hectic growth, symbols of the sun itself, the picture carried out with consummate attention to the subject's physical reality and yet invested with dramatic force.

London, National Gallery

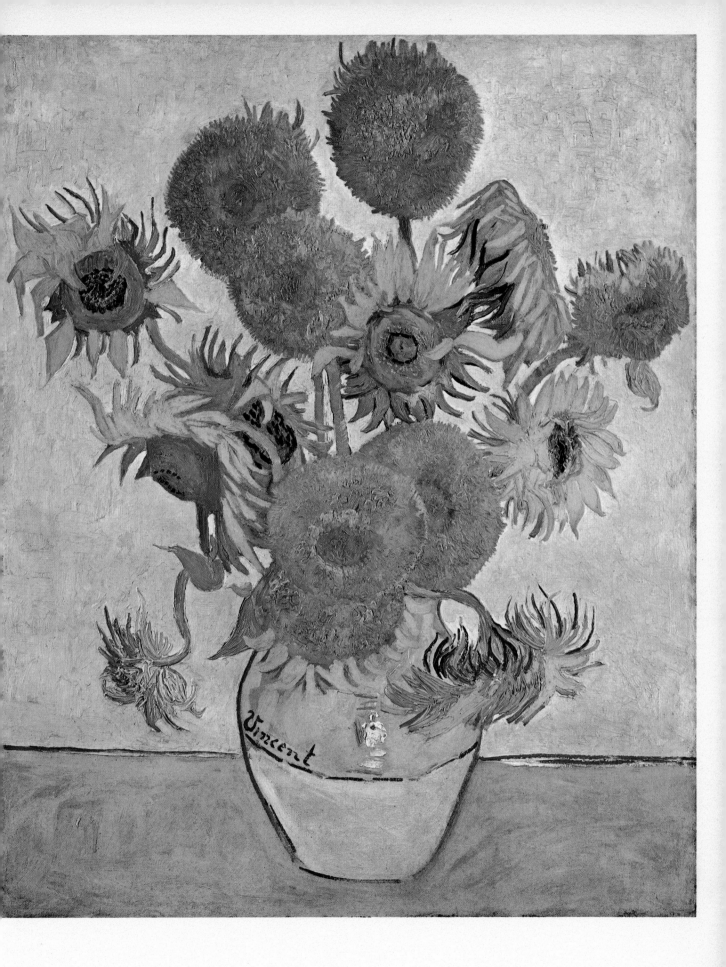

20. *The Yellow House*

1888. Watercolour. $9\frac{1}{2} \times 12in$ (24·5 × 30·5cm)

In the summer of 1888 van Gogh sent his brother this watercolour of the house he had rented, 2 place Lamartine near the Arles railway station. The famous oil painting of the subject, now in the same museum, was done at the end of September when he moved in. He had used one of the four rooms as a studio and ate his meals at the restaurant on the far left of the picture. Roulin and his family lived in a house between the two bridges on the right. Van Gogh had long been obsessed with the idea of a brotherhood of painters living and working together and his renting the yellow house was a major step in the realization of such a plan.

Amsterdam, Stedelijk Museum

21. *The Bedroom*

1889. Oil. 28½ × 36in (72·5 × 91·5cm)

'This time it's just simply my bedroom, only here colour is to do everything, and giving by its simplification a grander style to things, is to be suggestive here of *rest* or of sleep in general . . . you see how simple the conception is. The shadows and the thrown shadows are suppressed, it is coloured in free flat tones like Japanese prints.' This version was painted at St. Rémy in September 1889, a copy of the original of the previous autumn. 'When I saw my canvases again after my illness [his first breakdown] the one that seemed to me the best was the 'Bedroom'.'

Chicago, Art Institute

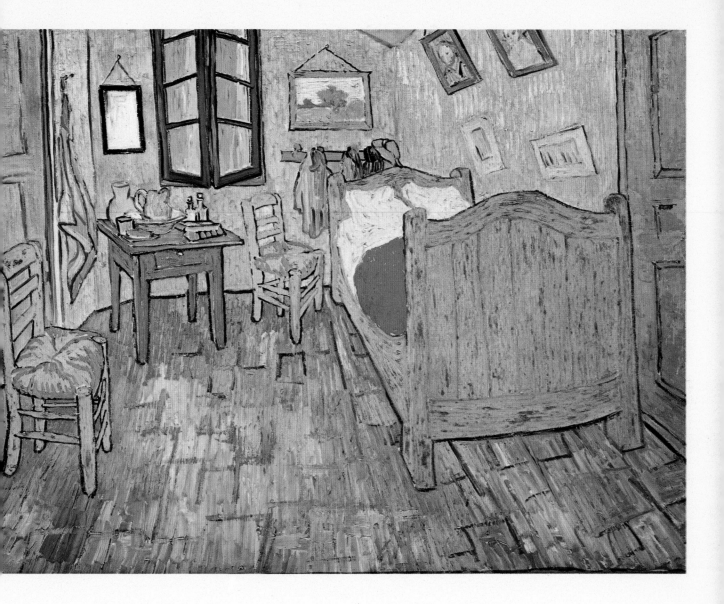

22. *Self-portrait with Shaven Head*

1888. Oil. 24⅜ × 20½ in (62 × 52cm)

This was painted in September and has a dedication, written along the top, to Gauguin who had sent him his own self-portrait. Van Gogh shows himself here hollow-cheeked and pale, the shaven head and bare neck accentuating such stark self-presentation. He has deliberately slanted the eyes making himself look, as he said, like 'a simple worshipper of the eternal Buddha'.

Cambridge, Massachusetts, Fogg Art Museum

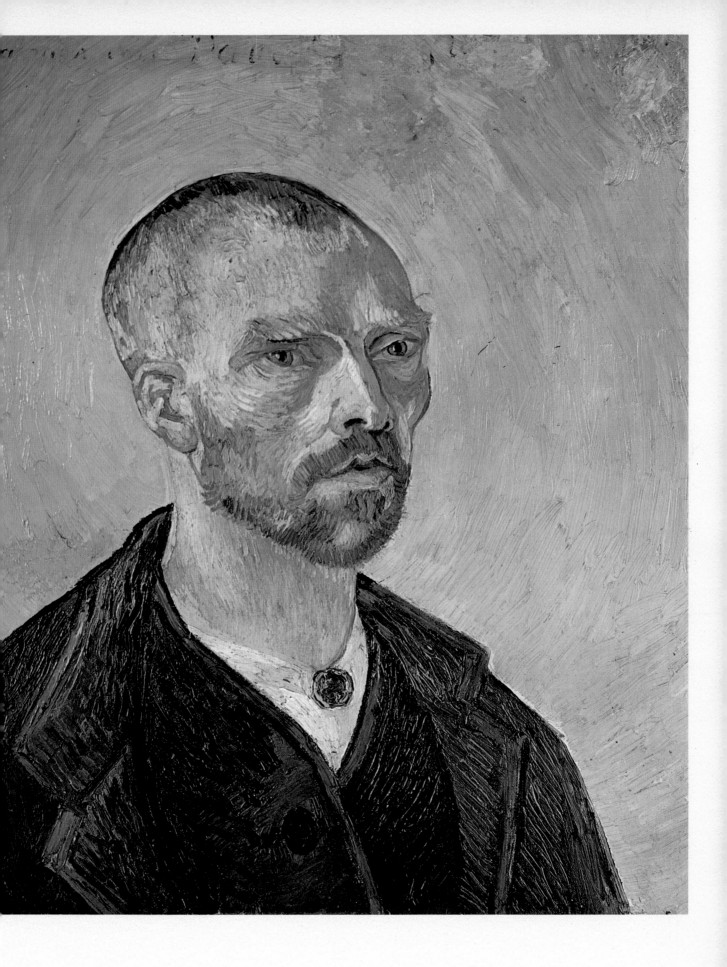

23. L'Arlésienne (Mme Ginoux with books)

1888. Oil. 35½ × 28½ in (90 × 72·5cm)

Mme Ginoux and her husband ran the Café de la Gare in Arles near van Gogh's house. Van Gogh and Gauguin persuaded her to sit to them in November and van Gogh later recalled that his whole portrait was completed in three-quarters of an hour. It is an astonishing performance, subtle in its characterization of a pensive woman in middle age, assured in its juxtaposition of brilliant primaries, terse and vital in its contour, once more showing van Gogh's penetrating transformation of the particular into an archetypal image.

New York, Metropolitan Museum of Art

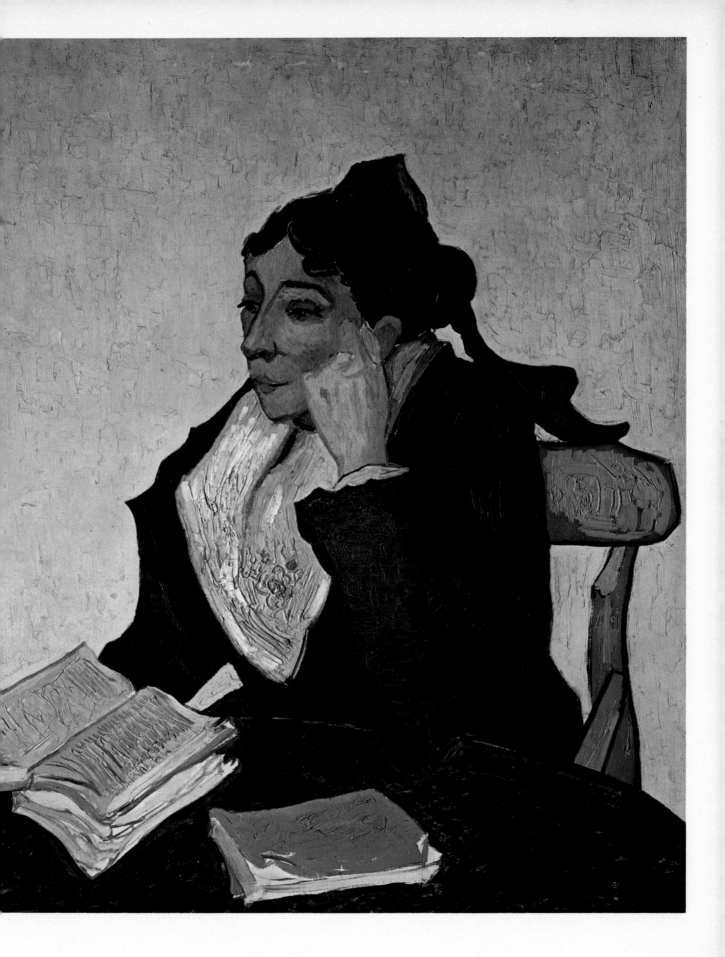

24. *Armand Roulin*

1888. Oil. $25\frac{5}{8} \times 21\frac{1}{4}in$ (65 × 54cm)

Van Gogh painted two portraits of the postman's sixteen year old son as well as studies of Armand's younger brother Camille and baby sister Marcelle. We have here one of the purest expressions of van Gogh's ability to suggest volume and modelling by the vivacity and sureness of his line. Of painting portraits he had written some months previously that it 'is the only thing in painting that moves me deeply, and which makes me feel the infinite more than anything else'.

Essen, Folkwang Museum

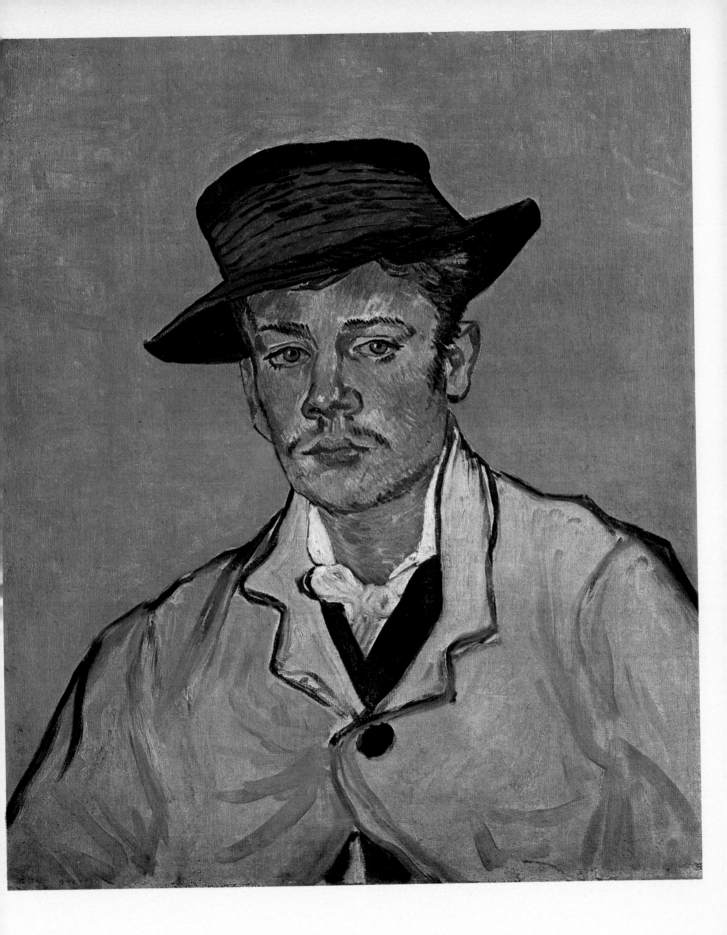

25. *The Sower*

1888. Oil. 13 × 16⅛ in (33 × 41cm)

The figure of a sower appears throughout van Gogh's work and is constantly evoked in his letters. He made drawings of sowers in the North, copied Millet's *The Sower*, and made two versions of the present subject. Delacroix's *Christ on the Sea of Galilee* – that 'sublimely brilliant conception' as he called it – was also much in his mind when he painted this picture, for he closely identified the imagery of fields and sea.

Amsterdam, Stedelijk Museum

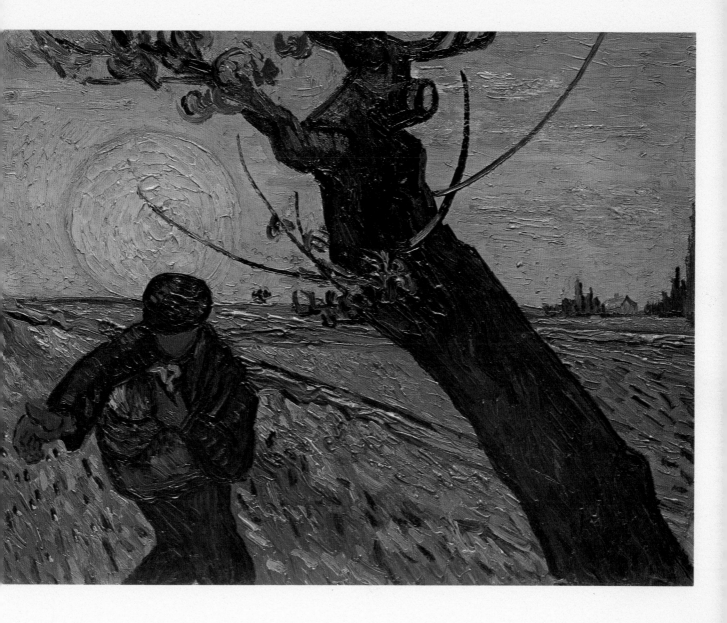

26. Chair with Pipe and Tobacco

1888. Oil. 35½ × 28in (90 × 71·5cm)

To prepare his house for what he hoped would be a brotherhood of painters, van Gogh bought twelve chairs, two of which appear in *The Bedroom* (*plate 21*). Another appears in *Gauguin's Armchair* – a more comfortable one with two novels and a lighted candle on its seat – which forms a pendant to the present picture. This painting was begun before Gauguin's hasty departure from Arles and taken up again when van Gogh's first mental crisis had passed. It is one of his most intensely conceived works, the chair becoming, through van Gogh's calculated exaggerations, a poignant emblem of stability in his threatened world.

London, Tate Gallery

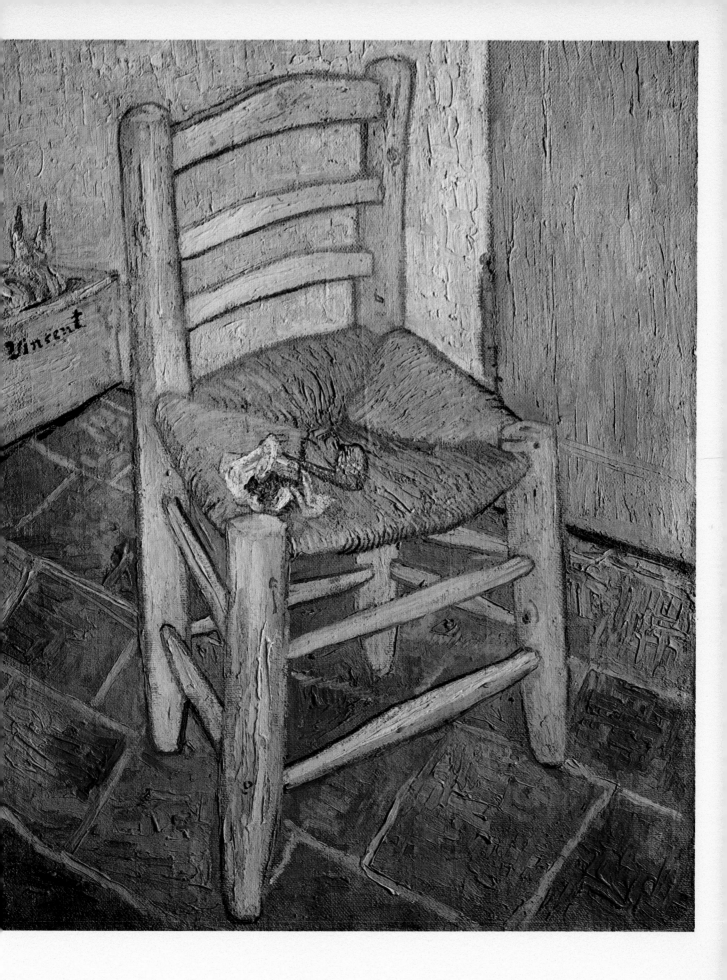

27. *Still Life with drawing board and onions*

1889. Oil on canvas. $19\frac{5}{8} \times 25\frac{1}{4}$ in ($49 \cdot 8 \times 64 \cdot 1$ cm)

In January 1889, after his release from the Arles hospital, van Gogh stayed indoors at home painting the two famous self-portraits with his bandaged ear and some still lifes. Here we see a collection of objects painted with a tenacious feeling for their familiarity, elements carefully chosen from the painter's life: food, drink, tobacco and pipe, an envelope addressed to him, a candle by which to read a book. The book is not, as one might expect, a novel by Maupassant, Loti or Zola, but, instead, *De La Santé* by F. V. Raspail, a well-known Parisian physician.

Otterlo, Rijksmuseum Kröller-Müller

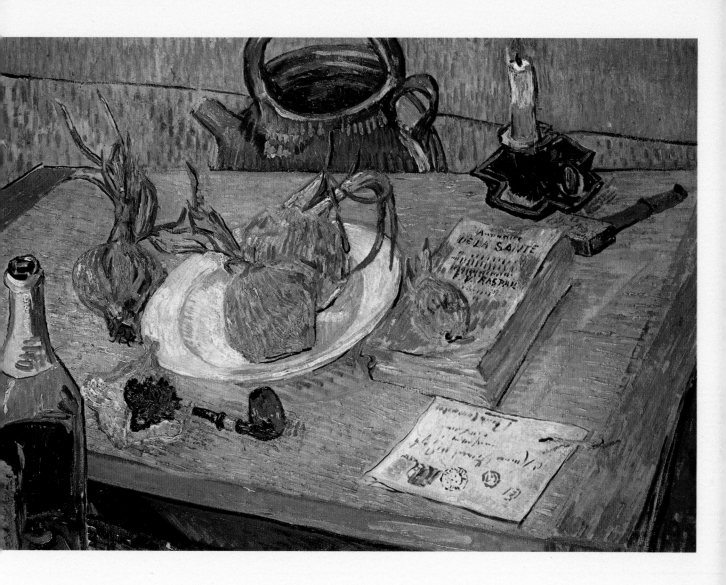

28. *Peach Trees in Blossom*

1889. Oil. 25$\frac{3}{4}$ × 32$\frac{1}{8}$ in (65·5 × 81·5cm)

This and the following plate were painted in April soon after van Gogh's recovery from his second attack when he remained in the hospital at Arles under the care of Dr Rey whose portrait he had painted in January. He returned to the theme of the previous spring – orchards in bloom among the gardens of La Crau, the plain stretching between Arles and the Alpilles seen here in the background.

London, Courtauld Institute

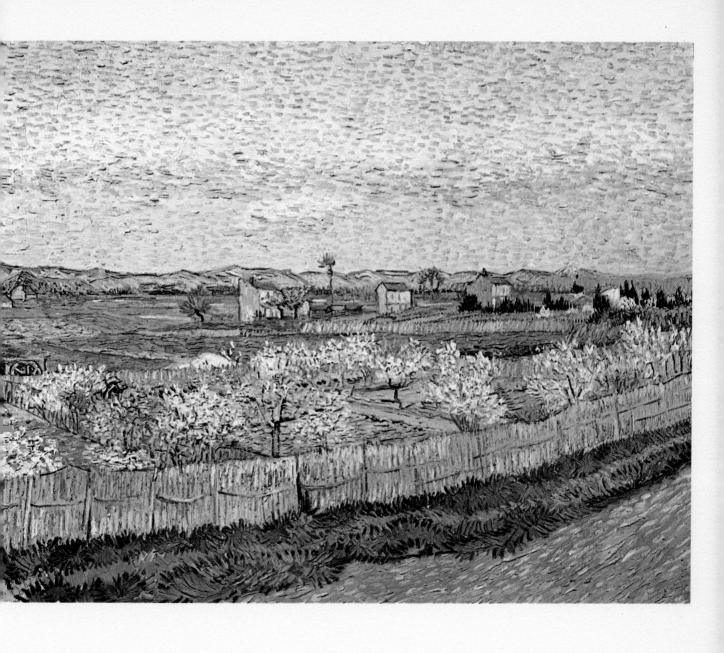

29. *View of Arles*

1889. Oil. 28⅜ × 36¼ in (72 × 92cm)

The familiar rooftops of Arles with the Romanesque tower of St. Trophime appear in several landscapes (e.g. *plate 12*). Here, the gnarled and sprouting trunks of the poplars appear almost like a barrier in front of the soft-toned, springtime trees and gardens. These trunks and the more sober colour of the picture foreshadow the curving forms and torrid brushstrokes seen in the *Landscape with Olive Trees* (*plate 32*).

Munich, Bayerische Staatsgemäldesammlungen

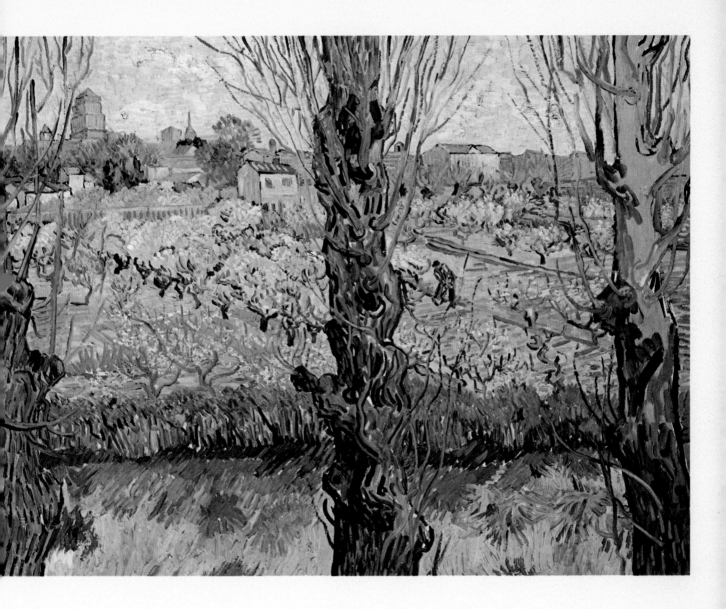

30. *The Hospital Garden at Arles*

1889. Oil. 28¾ × 36¼in (73 × 92cm)

Gardens are a recurrent theme of van Gogh's paintings and drawings, from the melancholy studies of the presbytery garden at Nuenen to Dr. Gachet's at Auvers. The raised viewpoint affording multiple perspectives again shows van Gogh's indebtedness to Japanese art; unlike the pictures painted in his last year, there is no loss of pictorial control or felicity of handling.

Winterthur, Sammlung Oskar Reinhardt, 'Am Romerholz'

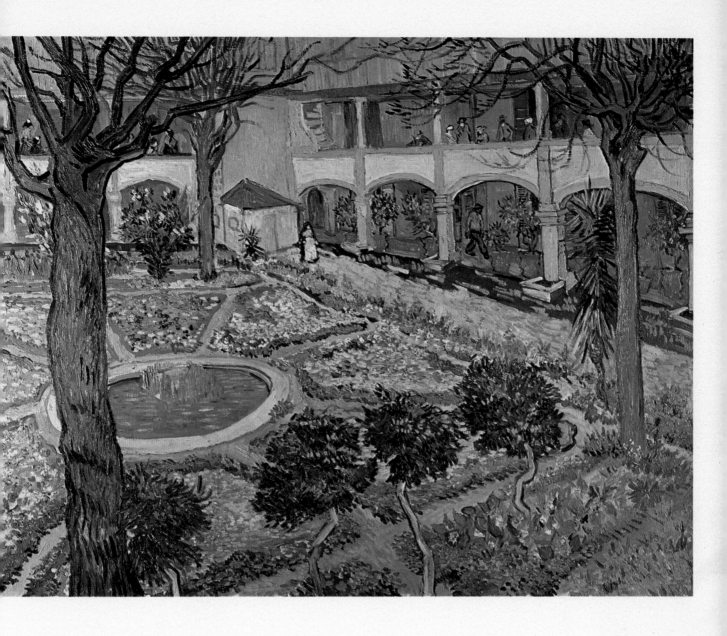

31. *The Starry Night*

1889. Oil. 28¾ × 36¼ in (73 × 92cm)

'The sight of stars always sets me dreaming just as naïvely as those black dots on a map set me dreaming of towns and villages. Why should those points of light in the firmament, I wonder, be less accessible than the dark ones on the map of France? We take a train to go to Tarascon or Rouen and we take death to reach a star.'

New York, Museum of Modern Art

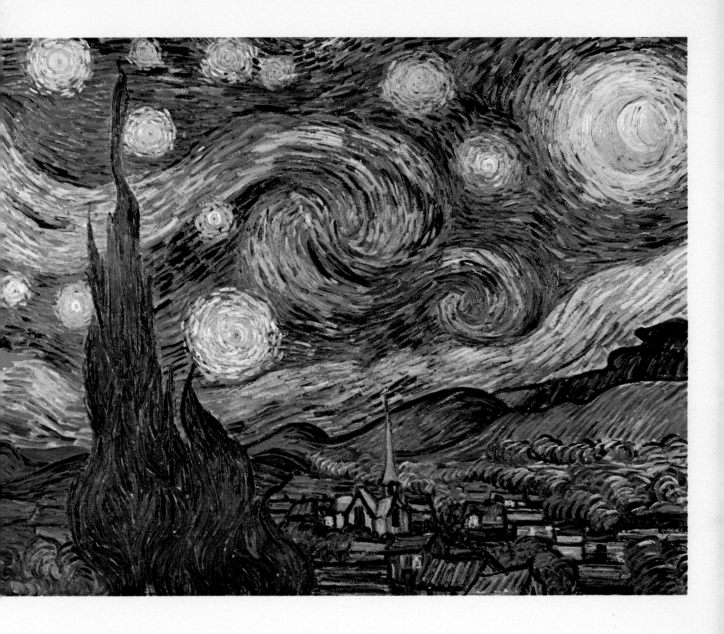

32. *Landscape with Olive Trees*

1889. Oil. 28½ × 35½ in (72·4 × 90cm)

In 1888 van Gogh attempted two canvases of *Christ in the Garden of Olives,* later destroying them both. He disliked portraying 'invented' biblical figures and expressed strong aversion to such scenes by Bernard and Gauguin. What interested him more was to paint 'the gleaning of the olives as you still see it, giving nevertheless the exact proportions of the human figure in it . . .' Here van Gogh has painted a dramatically charged olive grove in the characteristic style of his St. Rémy period, with its interconnected, undulating rhythms and curving brushstrokes binding together sky, hills and trees.

New York, John Hay Whitney Collection

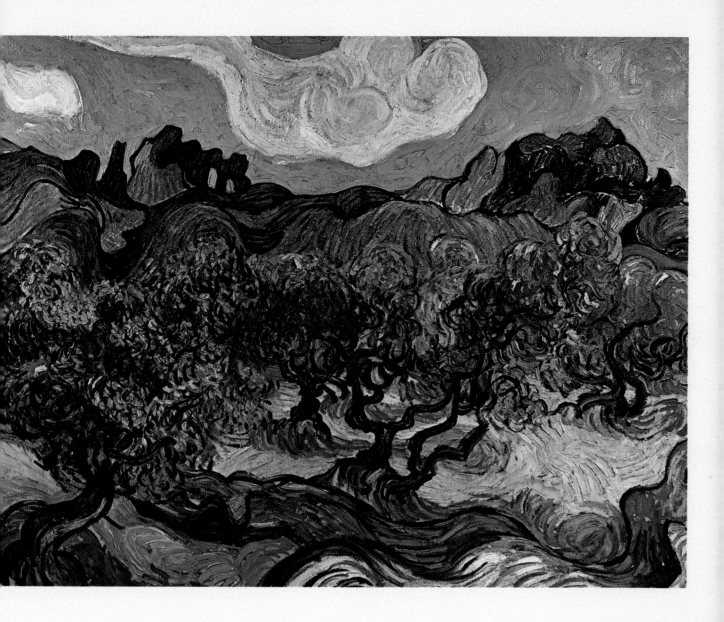

33. *Hospital Grounds at St. Rémy*

1889. Oil. 28¾ × 36¼in (73 × 92cm)

'This is a view of the grounds of the private hospital where I am living,' he wrote to Emile Bernard. 'Grey terrace to the right, with a section of the building. A few withered rose-bushes, with the grounds on the left, red ochre, parched by the sun and covered by fallen fir-twigs . . . The first tree has an enormous trunk, but it has been struck by lightning and sawn . . . This grim giant, an image of humbled pride, contrasts, if we consider the tree as a living being, with the pallid smile of a last rose on the fading bush facing it . . .' Van Gogh intended to convey the melancholy affliction of his fellow inmates through such calculated effects of colour and interrupted line; it is one of the most splendid harmonies of the last months of his life.

Essen, Folkwang Museum

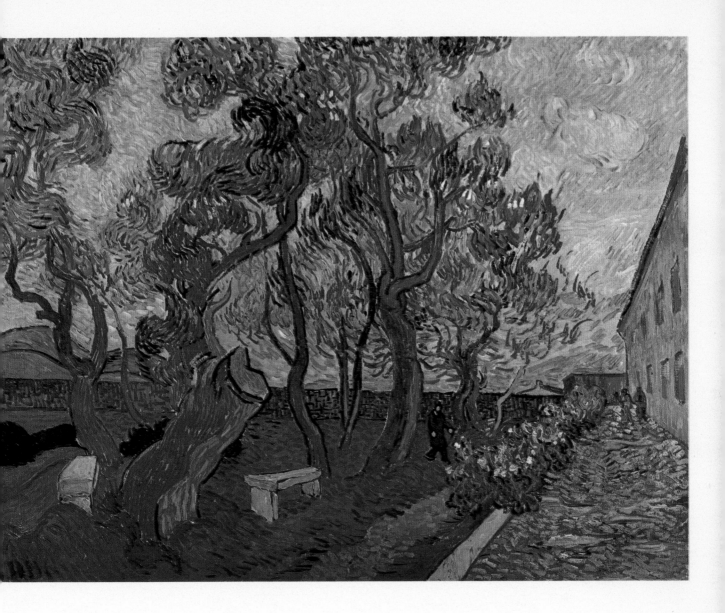

34. *The Open Door*
(St. Paul Asylum, St. Rémy)

1889. Gouache. $24\frac{1}{2} \times 18\frac{3}{4}$ in (62×47.5 cm)

The asylum of St. Paul-de-Mausole, on the edge of the
small town of St. Rémy in Provençe was originally a
monastery and became an asylum in the early nineteenth
century. When van Gogh went to live there (on May 8
1889) there were about a dozen mental patients, some of
whom were subject to violent outbreaks of insanity. Van
Gogh was given two cells, one for use as a studio, and
allowed to paint in the hospital and its grounds. He had
over seven attacks, some of them taking several weeks
from which to recover. Nevertheless he produced, while he
was there, over 150 oil paintings and about 110 drawings
and watercolours; the present one shows the lobby of the
asylum, its door opening onto the garden seen in *plate 33*.

Amsterdam, Stedelijk Museum

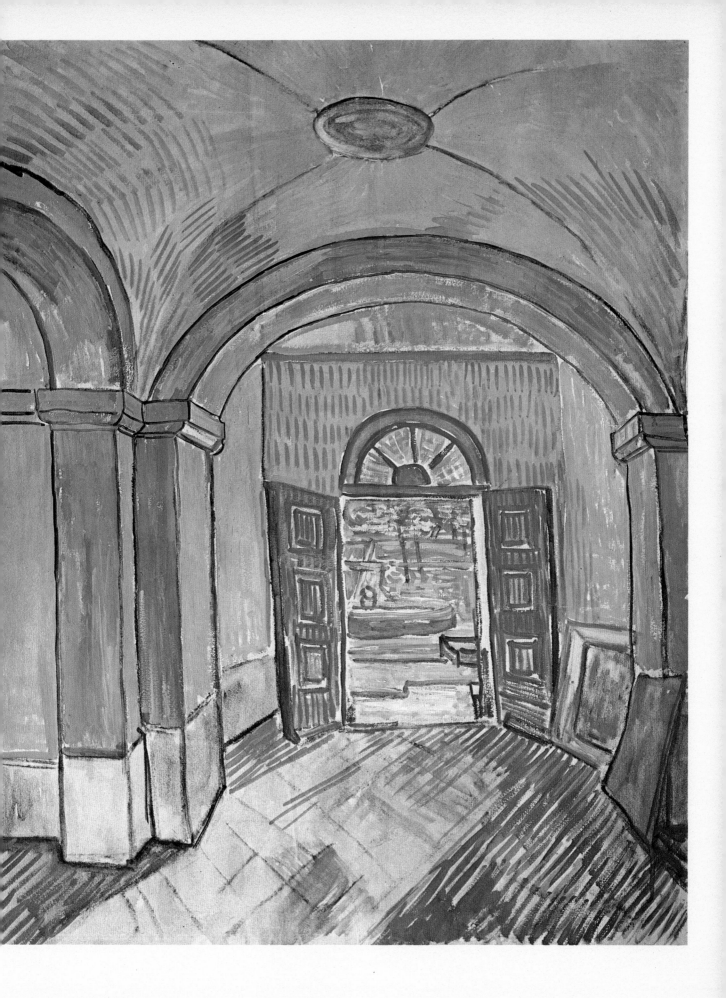

35. *The Good Samaritan (after Delacroix)*

1890. Oil. 28⅝ × 23¾ in (72·5 × 60·5 cm)

Locked up in his room in the asylum, van Gogh improvised a whole series of copies or paraphrases from black and white prints after works by his favourite artists: Rembrandt, Daumier, Doré, Millet and Delacroix. Usually he retained the composition of the work (except in Rembrandt's *Raising of Lazarus* where the sun replaces the figure of Christ) but invented his own colour schemes in what he regarded as an act of collaboration. Here he has transposed Delacroix's figures to the rocky landscape of Les Baux, near the asylum.

Otterlo, Rijksmuseum Kröller-Müller

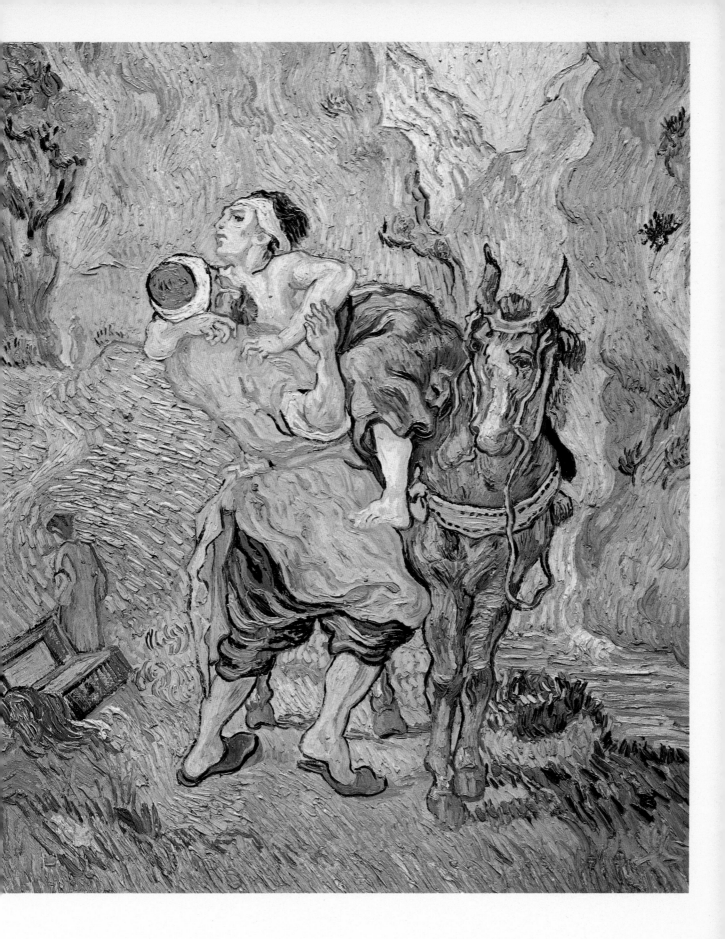

36. *Road with Cypresses*

1889. Oil. 35⅞ × 28in (91 × 71cm)

'Romantic' was the word van Gogh used to describe this painting. Like *The Starry Night* (*plate 31*) it evokes that synthesis of heaven and earth suggested by van Gogh's comment that 'we take death to reach a star'. The crescent moon, the sun and solitary star carry haloes of energy in an infinity of sky pierced by two twisting cypresses. There is something almost jaunty in the psychological and spatial inevitability of the 'two late wayfarers' and the cart behind.

Otterlo, Rijksmuseum Kröller-Müller

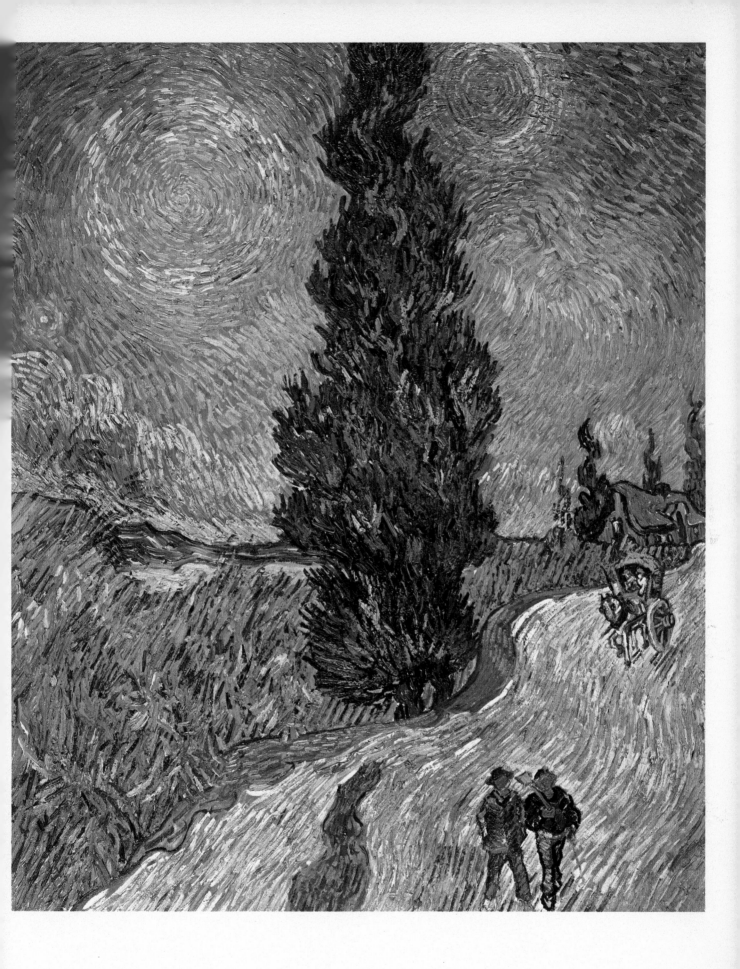

37. Self-Portrait

1890. Oil. 25½ × 21in (65 × 53·5cm)

'My surroundings here begin to weigh on me more than I can express – my word, I have had patience for more than a year – I need air, I feel overwhelmed with boredom and distress,' van Gogh wrote to his brother from the asylum. This self-portrait, painted shortly before he left St. Rémy shows some of the agony of that claustrophobia, a controlled anxiety, the eyes fiercely determined; this image of a man at the end of his tether is made more compelling by its superbly accurate delineation.

Paris, Musée du Louvre

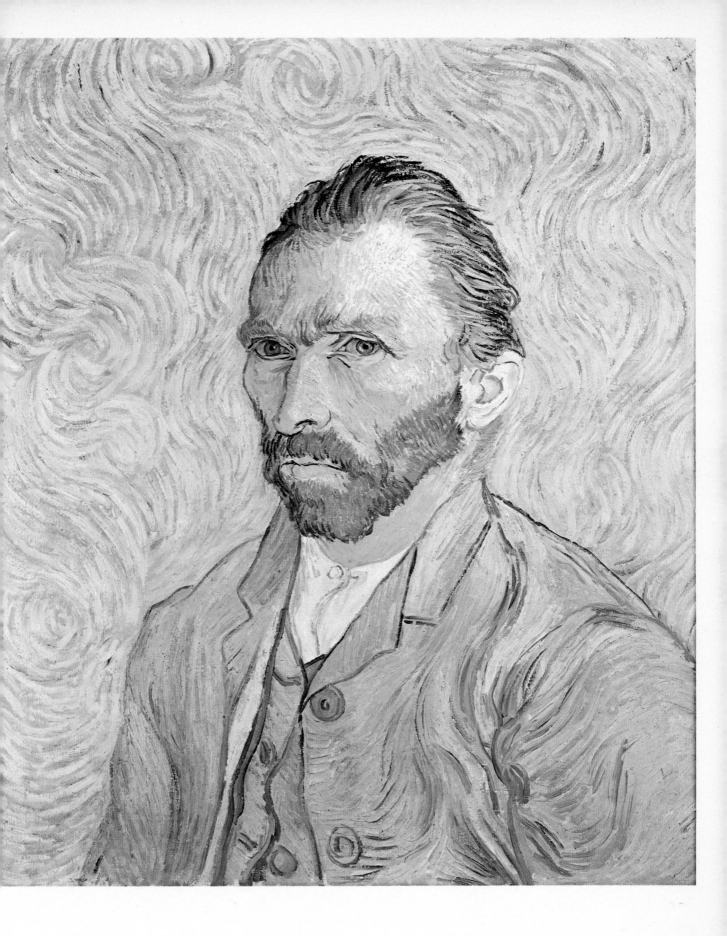

38. *Portrait of Dr. Gachet*

1890. Oil. 26¾ × 22½ in (68 × 57cm)

In May 1890 van Gogh left Provençe to live at Auvers-sur-Oise, a village north-west of Paris. He was under the care of Dr. Paul Gachet, an amateur painter, homeopath and friend of many Impressionist painters whose work he collected: Theo had met him through Pissarro. A close sympathy grew rapidly between painter and doctor explaining perhaps the success of this portrait, although others undertaken at Auvers were relative failures; van Gogh wrote that he wished to express in this portrait 'the heart-broken expression of our times'.

Paris, Musée du Louvre

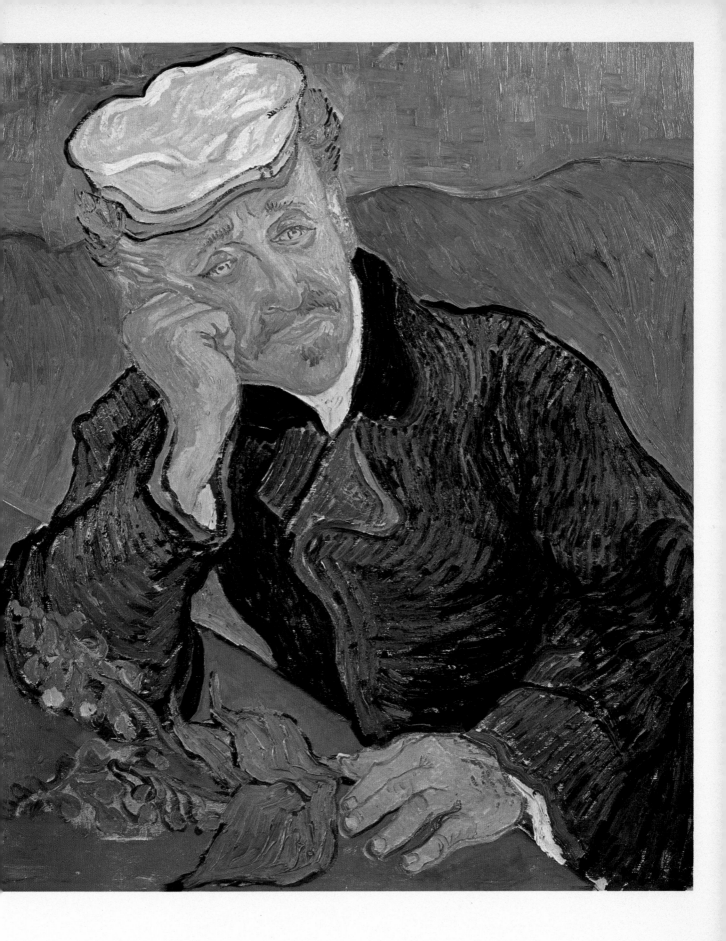

39. *The Steps at Auvers*

1890. Oil. $18\frac{7}{8} \times 27\frac{1}{2}$in ($48 \times 70$cm)

Van Gogh's move to Auvers marked a further change in his style. The writhing forms, half-tones and bristling strokes of much painting done at St. Rémy were replaced by a more linear, billowing construction; colour is lighter but rarely radiant; a flat decorative element enters many pictures. Fields and roofs undulate in restless curves; the skies become unnaturally agitated, often painted in broad, divided strokes reminiscent of mosaics. The picture's gaiety and rhythmic vitality distinguish it from other views of the village.

St. Louis, City Art Museum

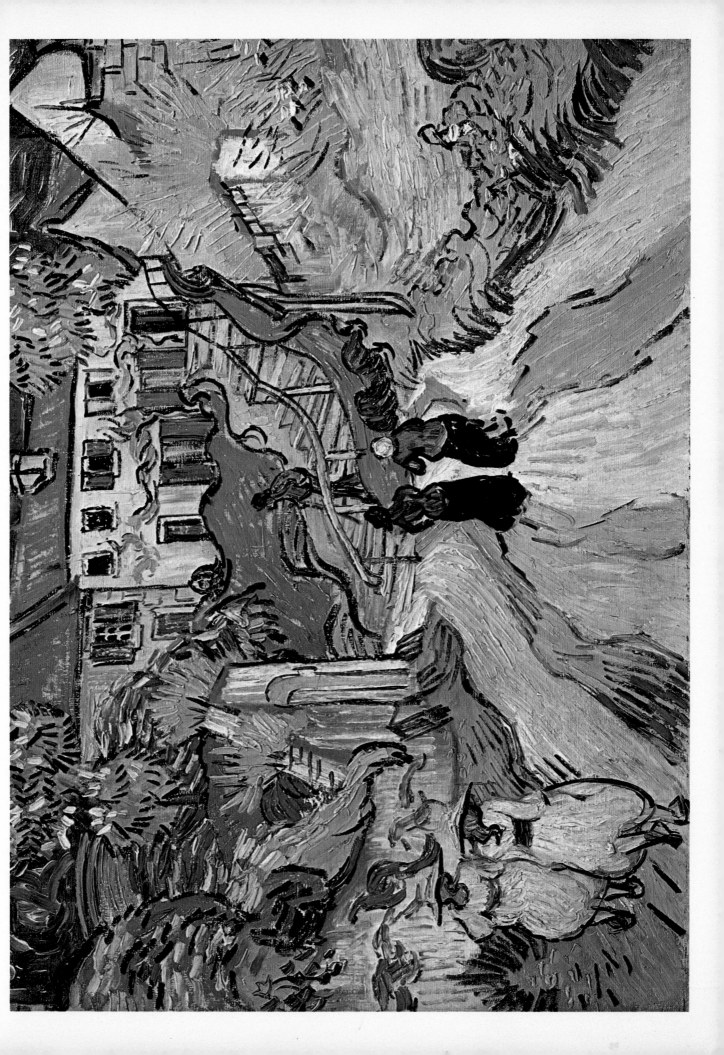

40. *View of Auvers*

1890. Oil. $23\frac{1}{4} \times 39\frac{3}{8}$in (59 × 100cm)

Auvers-sur-Oise, surrounded by hamlets and farm
buildings, extends from the river up hillsides to a fertile
plain, above which van Gogh frequently painted in his last
two months. His memories of Holland were intensified by
the thatched roofs and sandstone cottages of the area with
their cultivated gardens. There are over seventy paintings
from Auvers, many carrying signs of an almost desperate
haste; few are as well articulated as this apparently
unfinished one.

London, Tate Gallery

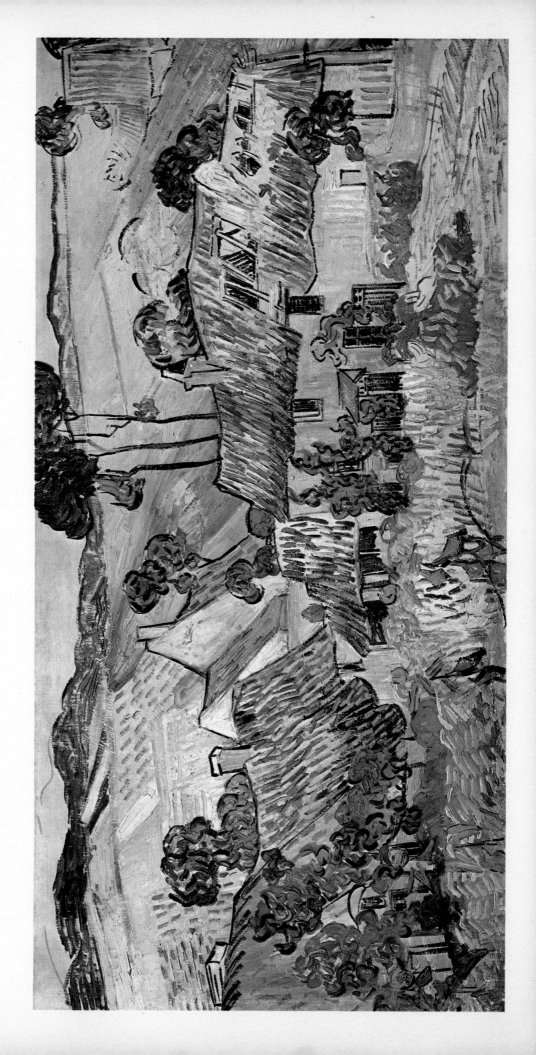

RICHARD SHONE AND BLACKER CALMANN COOPER LIMITED *would like to thank the galleries and owners who allowed works in their collections to be reproduced in this book. Plates 4 and 21 are reproduced by courtesy of the Art Institute, Chicago, plate 22 by courtesy of the Fogg Art Museum, Harvard University (Collection Maurice Werther), plate 31 by courtesy of the Museum of Modern Art, New York (acquired through the Lillie B. Bliss Bequest) and plate 19 by courtesy of the Trustees of the National Gallery, London. Clichés Musées Nationaux, Paris provided the transparencies for plates 6, 37 and 38.*